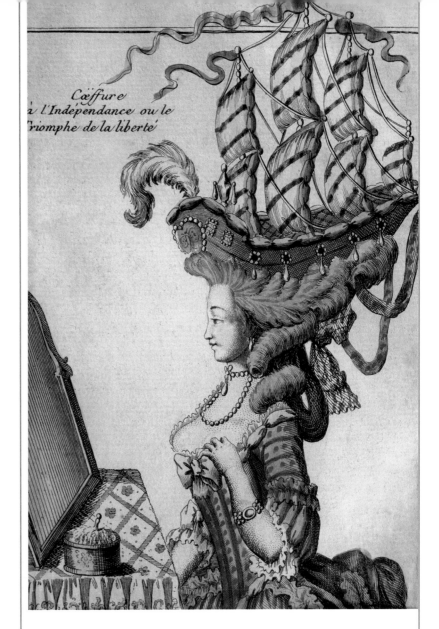

Cœffure
à l'Indépendance ou le
Triomphe de la liberté

A History of Fashion and Costume
Volume 5
The Eighteenth Century

Anne Rooney

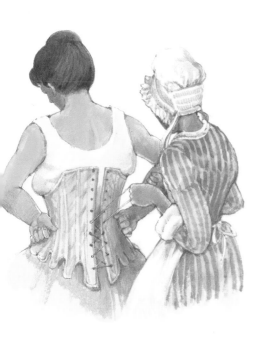

☑® Facts On File, Inc.

The Eighteenth Century

Copyright © 2005 Bailey Publishing Associates Ltd

Produced for Facts On File by
Bailey Publishing Associates Ltd
11a Woodlands
Hove BN3 6TJ

Project Manager: Roberta Bailey
Editor: Alex Woolf
Text Designer: Simon Borrough
Artwork: Dave Burroughs, Peter Dennis,
Tony Morris
Picture Research: Glass Onion Pictures

Consultant: Tara Maginnis, Ph.D. Associate Professor
of the University of Alaska, Fairbanks, and creator
of the website, The Costumer's Manifesto
(http://costumes.org/)

Printed and bound in Hong Kong

Facts On File, Inc.
132 West 31st Street
New York NY 10001

Facts On File books are available at special
discounts when purchased in bulk quantities for
businesses, associations, institutions, or sales
promotions. Please call our Special Sales
Department in New York at 212/967-8800 or
800/322-8755.

You can find Facts On File on the World Wide
Web at: http://www.factsonfile.com

**Library of Congress Cataloging-
in-Publication Data**

Rooney, Anne.
A history of fashion and costume.
 Volume 5, The eighteenth
century/Anne Rooney.
 p. cm.
Includes bibliographical references and
 index.
 ISBN 0-8160-5948-9
 1. Clothing and dress—History—
18th century—Fashion—History—
18th century.
 GT585.R66 2005
 391/.009/033—dc 22
2005040156

The publishers would like to thank the
following for permission to use their
pictures:

Art Archive: 9, 12, 17, 18,
32, 37 (top), 45, 47 (right), 49, 55
(both), 59
Bridgeman Art Library: 6, 7, 10 (top),
14, 16 (both), 27, 33 (top), 35 (both),
39, 41, 50, 58
Hanan and Farah Munayyer
Collection: 21 (top)
Peter Newark: 29 (both), 36, 38, 48
Topham: 26
Victoria & Albert Museum: 11, 23, 24,
25, 40, 42 (bottom), 44, 46, 52, 57

Contents

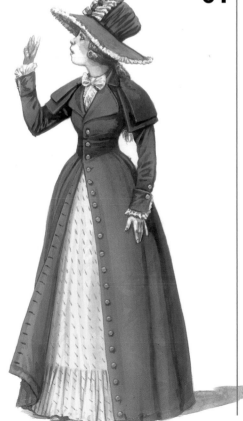

Introduction

The eighteenth century saw the beginnings of the modern fashion industry in Europe and America. Fashion magazines appeared and the first fashion plates were produced. For the first time, designs could be published and copied widely. Fashions began to change quickly, led by Paris and London. Designs were dictated not by practical needs but by trends in art, culture, and politics, by new discoveries, technological innovations, and scientific advances. Some European fashions were, in fact, so impractical they rendered their wearers almost incapable of everyday activity.

Elsewhere fashions changed slowly. In Asia, textile production was already greatly advanced and beautiful garments had been produced for centuries. Their designs evolved slowly, following traditional or symbolic patterns, and were often linked to the social and religious standing of the wearer.

In countries where the climate was warm, clothes could be basic or even non-existent; the concept of changing fashions was alien. In some places, simply structured garments were beautifully adorned, following patterns and styles used for generations without change.

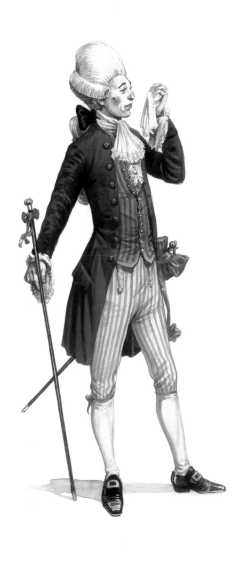

This book traces the developing fashions of the West. But it also looks at the strictly regulated clothing worn in the Far East, where choosing the wrong color robe could bring dire punishment. It visits the Inuit, who made clothes from fish skin and the intestines of sea mammals. It looks at clothing for special purposes, from the leather armor of the samurai to shamans' garments decorated with bones and bird beaks. People around the world have delighted in decorating their bodies and clothes. In their costumes, they leave a record of their lives, their concerns, and their beliefs that unlocks the past.

Chapter 1: Changing Fashions in the West

The clothes worn by the upper classes in France and England set the style for all of fashionable Europe and America. Although there was a lot of regional variation in the clothes of working people and those who lived in the countryside, the wealthy classes from Philadelphia to Moscow wore similar styles.

Women's Fashions: 1700–1750

The seventeenth century ended with women wearing a pointed, boned bodice with a wide gown open over an underskirt, often decorated with flounces. This style continued through the first decade of the eighteenth century, but was soon overtaken by the sack or sack-back dress.

The Sack Dress

The sack dress emerged around 1705, quickly became popular, and remained in fashion until the 1780s, although other styles were current alongside it after 1720. The sack dress was a very wide and rather shapeless overdress, with a gathered or pleated piece of fabric attached at the shoulder and flaring out toward the ground. The dress might cross over at the front. Sometimes the fullness of the skirt was caught up in slits in the underskirt, so that effectively the dress went into its own pockets. The front could be either open, to show an underskirt, or closed. The sleeves were flat at the tops of the arms, but flared out at the elbow, finishing with a stiff, pleated cuff.

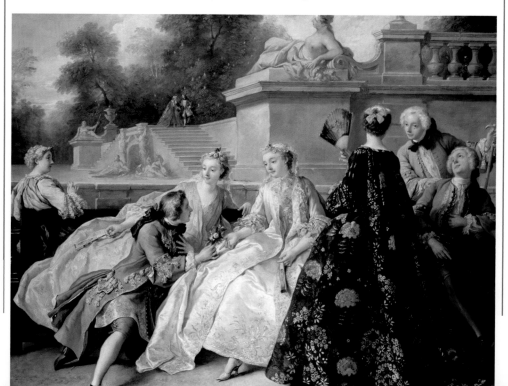

Sack dresses, 1731. The example in the middle is unusual in having a high neckline.

Paniers

The sack dress was given shape by a hoop or panier underneath. This was a wide framework of whalebone, cane, or metal hoops, held together with fabric and ribbons. The panier was at first circular, but the shape changed between 1725 and 1730, becoming oval and larger, with a circumference of up to eleven feet (3.35 m). Dresses became so wide that women often had to turn sideways to walk through doors. Later paniers were often made in two parts, one for each side. Paniers remained fashionable until the 1760s and continued as part of formal court dress after this.

French Fashion

A variation on the sack dress, the style *à la française*, began to appear around 1720. This had pleats falling loose from the neckline at the back, but a shaped front. A fitted bodice was fastened to either side of a triangular stomacher, a piece of richly decorated fabric over the chest. Sometimes it was replaced by or decorated with a ladder of bows of decreasing size.

The over-gown opened widely over a decorated petticoat and was edged from the hem, around the neck and down to the hem again, with a frill or puffed edging. The sleeves were cut to show a cuff of lace flounces beneath, shallow on the inside of the arm but quite extravagant on the outside.

The Marquise de Pompadour wearing a very ornate dress in the *à la française* style.

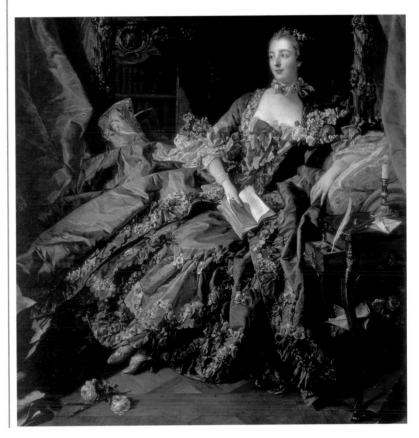

Spinning and Weaving Technologies

England was preeminent in spinning and weaving cloth. During the eighteenth century, several inventions mechanized cloth production, making it easy to make quality cloth quickly and cheaply. Fabric woven manually could only be as wide as the distance between a person's outstretched hands, because the shuttle had to be passed from hand to hand. The invention of the flying shuttle in 1733 meant that wider fabrics could be woven. Spinning technology improved with the spinning jenny (1764) and then the spinning mule (1779), which could spin strong, fine thread good enough for making muslin.

Men's Fashions: 1700–1770

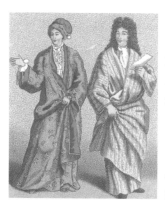

In Europe and America, men's clothing changed only slowly for most of the eighteenth century. France and England led Europe in men's fashion as in women's.

Two men wearing banyans. The man on the left has replaced his wig with a cap.

Three Essential Garments

Men's dress was characterized by knee-length trousers, called breeches, worn with stockings, a waistcoat, and a coat called a *justaucorps*. At the start of the century, the formal, or full dress, coat had a wide skirt and large sleeves with extravagant cuffs, turned back, and no collar. It buttoned from the neck to the hem and came nearly to the knee, almost covering the breeches. It had large pockets and vents (slits) with pleats at the back and sides, allowing the skirt to move freely. By 1715 it was common to wire the hem to make it stand out. For informal wear (undress), and among working men, a coat called a frock was worn. This was of the same style, but less rigid and with a small, turned down collar.

The sleeved waistcoat was nearly as long as the coat itself. It, too, buttoned all the way down the front. Beneath the waistcoat a man wore a white shirt with lace flounces at the cuffs and down the front. A lace cravat at the neck served instead of a collar until 1735. Later, a stock (stiffened neckband) was worn, sometimes with a black tie called a solitaire. The coat was often worn open to show the waistcoat, and later the waistcoat was open to the waist to show the lace on the shirt. The breeches were full and fastened at the knee. White or colored silk stockings were rolled over the bottom of the breeches and fastened with a garter. Later in the century, and for working men,

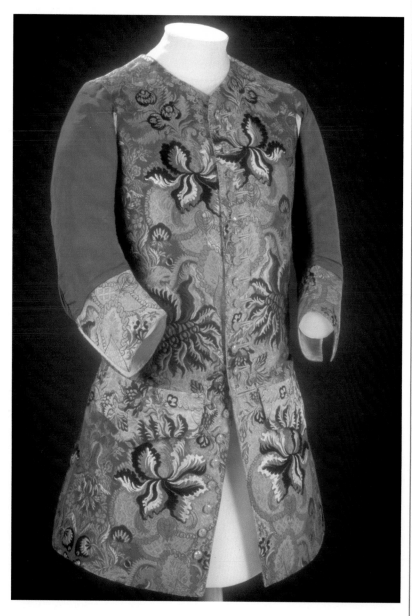

This waistcoat is embroidered only on the visible parts – the back and most of the sleeves are plain.

the breeches fastened over the stockings.

Changing Shapes

As the century progressed, the skirts of the coat and waistcoat became narrower. Waistcoats became shorter, no longer buttoned to the hem, and lost their sleeves. Coat sleeves became closer fitting, and the cuffs first narrowed at the wrist and finally became less flamboyant. From the 1730s onward, the front of the coat curved back to show the breeches, and could be buttoned only to the waist, although it was unusual to see it buttoned at all. The breeches were cut closer to the leg, so that the whole profile was slimmer.

Hats and Wigs

From around 1715, wigs were powdered and worn long and curled, with the hair falling down on either side of the face. Because this was inconvenient, there was a change during the century to shorter wigs, with the hair tied in a pigtail at the nape of the neck and, later, held in place in a black silk or gummed taffeta bag.

At home or in their place of business, men removed their wigs and wore

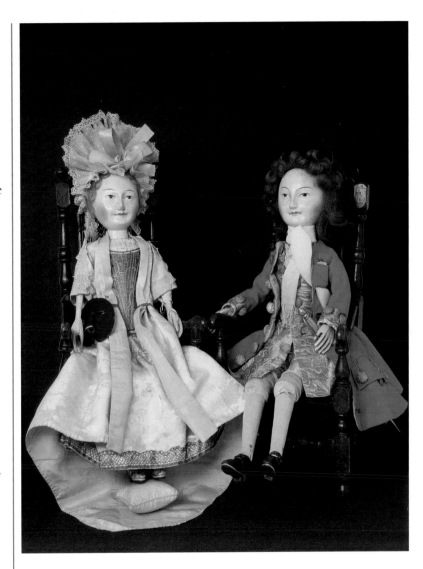

small, embroidered caps instead. Tricorn (three-cornered) hats were decorated at first with feathers or ribbon and, later, a simple braid edging. They were often carried rather than worn.

Information about current fashions crossed the English Channel in the form of fashion dolls, or moppets, dressed in current styles.

Undress

Indoors, particularly during the morning, men often wore a loose dressing gown called a banyan over their breeches and shirt. This was often made of silk damask and sometimes richly embroidered. In winter a quilted silk banyan could be worn. Writers and artists are often shown in portraits wearing a banyan and cap, a style which became associated with intellectual activity. In the American South, thin cotton banyans were even worn outside by planters and their wives.

Women's Fashions: 1750–1780

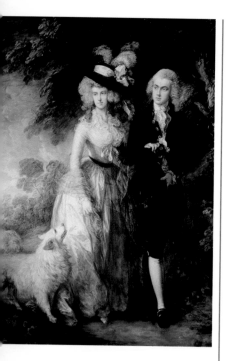

In this portrait, the woman is dressed *à l'anglaise.*

Women's fashions multiplied rapidly in the middle of the eighteenth century, with one style following another in quick succession. English styles were popular and had considerable impact on French dress, as did influences from the Orient and the Middle East.

In the court of Louis XVI in France (reigned 1774–1792), dresses became extremely ornate and extravagant, a reflection of the excesses of the aristocratic life that fuelled the French Revolution in 1789. In general, English styles were more restrained than French ones.

The Style *à l'Anglaise*

Enthusiasm for English styles began in France in the last years of the reign of Louis XIV (reigned 1643–1715) and took hold in 1755. In women's fashion, it produced the style known as *à l'anglaise*. The bodice was boned at the seams, but softer than the very structured French style. It formed a point at the back, meeting a skirt that had a short train gathered at the hips and was supported not with a panier but with a simple, padded bustle. The front had a plunging neckline, usually filled in with a linen fichu, a triangle of fabric worn over the shoulders and neck. The skirt opened widely over an underskirt.

The Redingote

Another English style was the redingote, developed from riding costume and popularized in continental Europe after the first horse races in Paris. This had a fitted bodice, buttoned at the front and sometimes crossing over like a man's greatcoat. The skirt could be closed, or open to reveal the underskirt. It was often worn with a huge, feathered hat, also English in origin.

À la Polonaise

Particularly popular in the French court was a style called *à la polonaise*, meaning "in the Polish style" (though it was probably never worn in Poland). The overskirt was drawn up over the hips by two drawstrings so

A redingote, worn open to show the underskirt.

A Riot of Color

Scientific work on the nature of color and the spectrum prepared the ground for the development of new dyes. Newton's *Treatise on Optics* (1704) explained that all other colors were formed by combining red, yellow, and blue. Johan Tobias Mayer in Gottingen claimed that 9,381 colors could be distinguished by the human eye.

Chemical dyes and pigments—derived from minerals, plants, and lichens—were developed, and by the end of the eighteenth century a range of colors in bright as well as subtle and muted tones could be achieved. Bleaching with chlorine was discovered in 1774 and went into commercial operation in 1786.

Color printing on fabric, legalized in England and France after 1759, produced good results. Copperplate printing was invented in 1757, followed by roller printing in 1783. This enabled large-scale, industrialized printing on fabrics, so that printed patterns became popular and widespread.

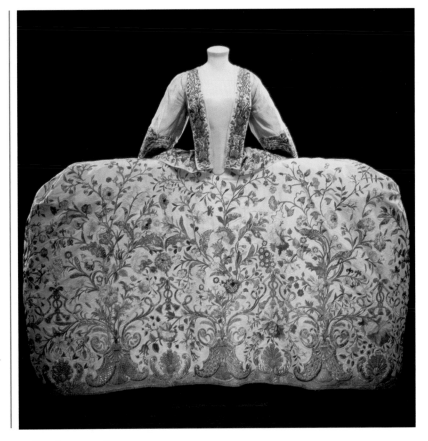

A mantua, or court dress, with a very wide skirt. It is made of silk, embroidered with silk and silver thread.

that it fell in three swags, two at the sides and one at the back. The dress was quite short, sometimes coming just to the ankles. It had flat sleeves that usually ended above the elbow, though a flounce of lace or muslin fell over the elbow.

Spanish Variations

While the upper classes in most European countries copied French fashions closely, the Spanish varied it slightly from the middle of the century. Spanish women wore their dresses somewhat shorter and lighter than in France. They added shawls in brilliant colors, and wore the traditional Spanish mantilla, a kind of lace veil in black or white supported by a tortoiseshell comb in their hair.

Men's Fashions: 1770–1830

The man's profile slimmed down during the last decades of the eighteenth century, and the slender shape remained fashionable until the 1830s. The flamboyant brocades of the earlier eighteenth century gave way to finer fabrics in plain colors or stripes, and all adornment slowly vanished.

The Frock Coat

From the middle of the century, the front of the coat was cut away, so that the sides swept away from the waist. The coat remained long at the back where it fell into three parts with two vents. Based on English riding clothes, this design was called the frock coat or redingote, and it influenced women's fashion, too.

By the early years of the nineteenth century, the back vents had come closer together and were combined so that the skirt of the coat fell in two "tails." This is the origin of the tailcoat, worn to this day for formal weddings and balls.

The Waistcoat

The origins of the modern waistcoat date from the early nineteenth century, too. No longer buttoned to a straight hem, the waistcoat ended in two points on either side of the front fastening.

From Breeches to Trousers

Breeches became closer-fitting during the eighteenth century, and

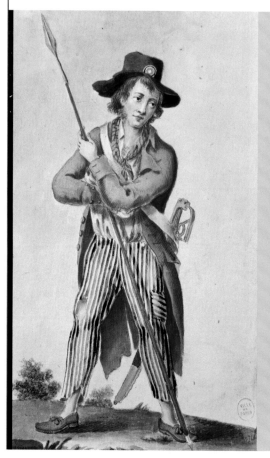

The costume of the sans-culottes: trousers, a cut-away coat with tails, and no wig.

The Sans-culottes

The French Revolution in 1789 saw the overthrow of the French aristocracy and king by the middle and lower classes. The revolutionaries were called the sans-culottes after their clothes—*sans-culotte* is French for "without breeches." They disdained the ornate breeches of the aristocracy in favor of the trousers worn by working men. By abandoning the fashion of the day, the revolutionaries declared their solidarity with the working classes and their rejection of aristocratic French society.

after the French Revolution a fashion for trousers replaced them. Adapted from the dress of sailors and the working classes, trousers were soon worn in a close-fitting style that was suitable for riding, often with soft leather boots which came to mid-calf or the knee.

Dandies and the Macaroni

While some men were abandoning unnecessary adornment, fops or dandies embraced it. The most famous dandy was Beau Brummell (1778–1840), a friend of the English prince regent (later George IV). Brummell reportedly spent all of his inherited fortune on fine clothes.

A group of dandies referred to as the Macaroni in the 1770s and 1780s were young British men who adopted the high fashion of France and Italy. Their style was fussy, overdressed, highly ornamented, and frivolous. They wore powdered wigs, tiny tricorn hats, and nosegays (posies of flowers). Not surprisingly, they were the butt of many jokes and were caricatured ruthlessly. The lines in the song "Yankee Doodle,"– "Stuck a feather in his hat, And called it Macaroni," – refer to the pretensions of a Yankee aspiring to European fashions by putting a feather in his outmoded hat.

Wigs to Real Hair

Toward the end of the eighteenth century, wigs were discarded by many men in favor of a wild, tousled hairstyle known as the *herisson* ("hedgehog" in French).

The tricorn hat, which had become smaller and less ornate during the middle of the century, was abandoned in Europe (though it was retained in America). Instead, a tall beaver hat was worn.

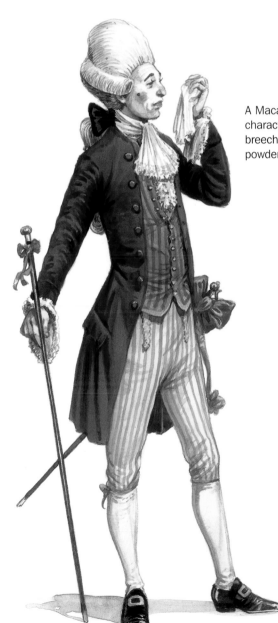

A Macaroni wearing characteristic striped tight breeches, and high, powdered wig.

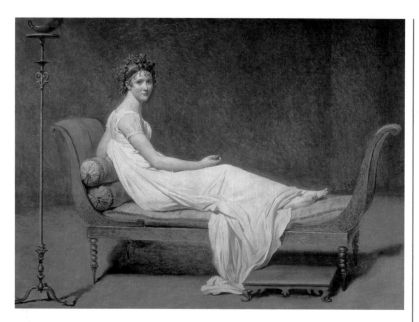

The Grecian style of her dress is continued in the woman's hairstyle and bare feet.

In the late eighteenth century, fashion was influenced by new directions in political and social thought that changed the way people considered themselves and their bodies. There was a move away from ornate and constricting clothes to more fluid shapes that followed the line of the body.

Rejecting Riches

From 1783 onward, the French court followed the lead of the queen, Marie Antoinette, in abandoning the huge, ornate, and constricting dresses of the previous years for all except the most formal occasions. By the time of the French Revolution in 1789, the most extravagant excesses had already been abandoned by most fashionable people. During the revolution, ostentatious displays of wealth became not only unfashionable but even dangerous.

English styles remained popular. Dresses had a softer line, or were

based on the redingote, and supported by light padding. A fine linen fichu was often worn over the chest, and the ribbons, bows, lace, and jewels of the 1770s disappeared. Dresses were usually in plain colors or stripes, unadorned except for a simple sash and sometimes a decorative apron. Ideals of rustic simplicity became popular. Patterns, when they were used, were inspired by nature, showing delicate flowers and leaves.

Slimmer Lines

In the early to mid–1790s, a shift dress or chemise made of thin cotton in white or pale colors became popular. The skirt began directly under the bust and fell to the floor with no further shaping, flowing around the body. Sleeves were small and puffed, necklines often square. In France, a few women, called *les merveilleuses,* took the style to extremes, wearing dresses so thin and flimsy they were thought indecent.

Although outside France dresses were heavier, they followed the same style. Around 1800 they became more substantial in France, too. The style, called the Empire line, was modified slightly in the early years of the nineteenth century, often having a length of pleated fabric at the back that fell like a train or an overgown. Richer colors and heavier fabrics eventually replaced the fine muslins. The waist remained high, and the sleeves were either short and puffed or, later, long and close to the

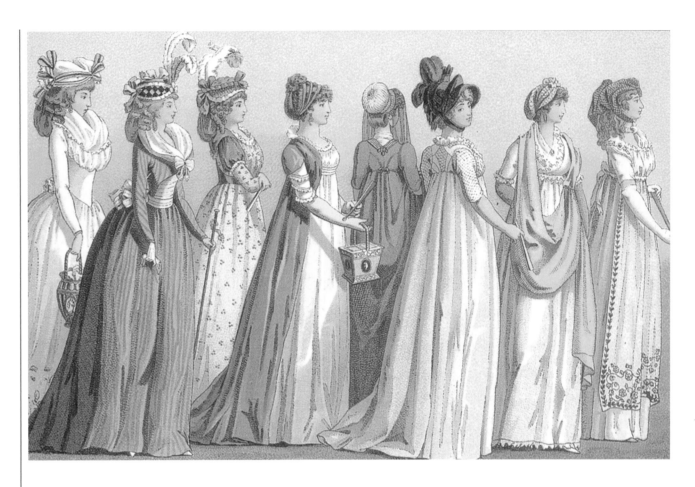

Women in transitional dress (on the left) and characteristic Empire-line dresses.

lower arm, though often still puffed at the top. Long kid gloves were worn for warmth with short sleeves.

Keeping Warm

With dresses of thin fabrics and no room for padded undergarments, women wore cashmere shawls, capes, or jackets for warmth. A very short jacket that stopped just below the bust, called a spencer, appeared in 1797. A pelisse, a cape-like coat with loose half-length sleeves and fur trim, was also popular.

The End of an Era

Exaggerated shapes resurfaced from 1820 to 1830, with very puffed sleeves, slender waists created by boning, and skirts becoming wider again, preparing the way for the wide skirts of the mid- and late nineteenth century.

The Cotton Trade

The booming trade in cotton helped the growing popularity of light dresses, and the demand for them in turn fueled the cotton trade. Cotton was grown in the southern American states, on plantations worked by slaves from Africa. The trade was based on a triangular shipping route that took slaves from Africa to America, raw cotton from America to the mills of Europe, particularly England and France, and then took finished goods to Africa. Slavery meant that cotton could be produced cheaply and in great quantities. Moves to abolish slavery, beginning in the late eighteenth century, met with huge resistance from those who profited from the cotton trade.

Children's Clothes

Attitudes toward children and childhood changed during the eighteenth century, influencing the way they were dressed. At the beginning of the century, even quite young children wore miniature versions of adult clothes, but by the end of the century they were wearing more suitable outfits that allowed freer movement.

Babies

In many parts of the world, babies were tightly swaddled—wrapped in bands of fabric—and often strapped to wooden "cradle boards." This was thought to encourage their limbs to grow straight. In Europe, swaddling dropped out of favor during the eighteenth century, and among educated people it had been abandoned completely by about 1780. However, many children wore stays (boned corsets) to encourage straight posture and correct growth.

Here, the girl wears a soft shift dress and the boy a skeleton suit of attached trousers and jacket.

Babies wore instead a cotton or linen shirt covered by a wraparound robe with separate sleeves, or a long frock that opened at the back. These came below the feet until the baby began to walk. Babies' heads were kept covered at all times with caps—often a forehead piece, then a close-fitting undercap, and finally a decorated cap.

Toddlers

Once children learned how to walk they needed different clothes. Both boys and girls wore a back-fastening bodice and a skirt to the ankles when very young, or sometimes a front-opening or wraparound gown. This allowed for easy diaper changing. In the second half of the eighteenth century, a looser frock with a sash at the waist was popular. Frocks or gowns often had leading strings or reins attached for an adult to hold while the child was learning how to walk. In the early decades of the nineteenth century, the dress was slightly shorter and worn with loose trousers, called pantaloons.

While the youngest children wear simple white dresses, the older ones wear clothes similar to those of the adults.

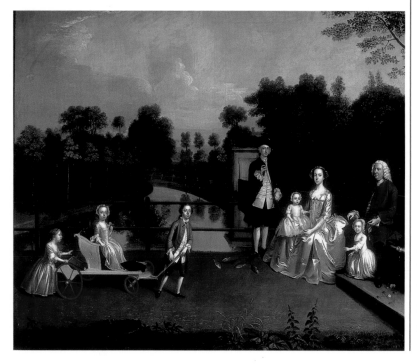

Dressed like Adults

In the first half of the eighteenth century, children were dressed in the same styles as adults, adapted only slightly for their different needs. Even quite small girls wore hoops or paniers and boned bodices. They always wore an apron to protect their clothes. Boys wore frock coats and ornamented waistcoats, and often even full-bottomed wigs or powdered hair. For everyday wear, they might leave off either the frock coat or the waistcoat and wear their breeches open at the knee, but for formal wear their clothes were the same as those of their fathers.

More Freedom

By the 1770s and 1780s, children were wearing looser clothes that made it easier for them to move around and play. Boys began to wear trousers rather than breeches. Between 1780 and 1820, boys up to the age of ten wore a "skeleton suit." This consisted of trousers worn over and buttoned onto a jacket.

Girls and small boys began to wear light shift dresses before the style became popular for women. The waist of the dress was high and covered with a sash. They often wore a muslin shift over a taffeta or silk underdress.

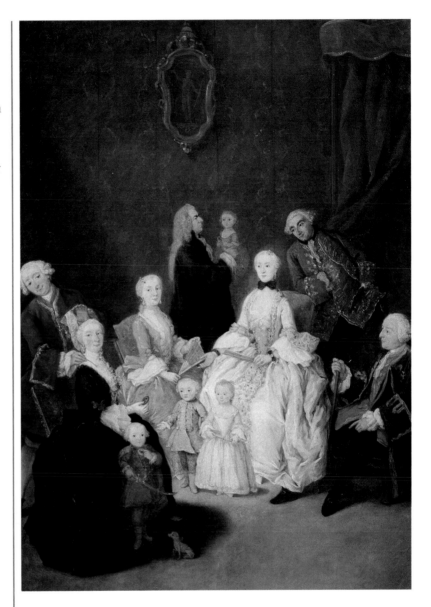

These Venetian children wear the same styles of clothes as their parents.

Breeching

At three or four, boys were "breeched," meaning that they began to wear breeches instead of a dress. Breeching was celebrated as an occasion that marked the end of young childhood and the point at which the boy was ready for education or, in poorer circles, work. Not only his age but a boy's height helped to decide when he was breeched—a short boy might have to wait until he was a little older. The breeching ceremony continued even after boys began to wear trousers instead of breeches.

Chapter 2: Worn Around the World

Heading East

While French and English fashions dominated western Europe and North America, their influence decreased farther east and outside the colonial centers in America. In some areas, very cold or very hot weather dictated what people wore. Costume was also restricted by the technologies and materials available to make clothes.

In eastern Europe and Russia, the influence of Persian and Turkish dress can be seen, tempered in the north by a need for warmth.

Poland and Eastern Europe

European fashions were popular in the Polish royal court, but elsewhere traditional Polish costume had a strong hold. Upper-class men wore a long, tight-fitting garment called a *zupan*, covered with a *kontush*, a coat with long, hanging sleeves that was Persian in origin. The kontush was smooth at the front but pleated at the back, the collar either upright or folded back. In 1776 a government decree in Poland and Austria imposed color-coding on the zupan and kontush, with standardized colors and trimmings for each province.

Women wore a long dress with close-fitting sleeves and an overdress similar to the kontush. This was open from the waist and nearly always trimmed with fur. The sleeves and front of the dress beneath were visible.

Traditional peasants' costume was a short tunic with long trousers worn with a long cloak or overcoat of sheepskin, and boots or shoes woven from strips of bark.

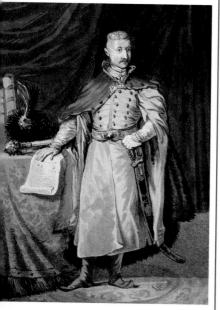

A Polish soldier with a cloak over his *kontush*. The red leather boots show that he is of noble birth.

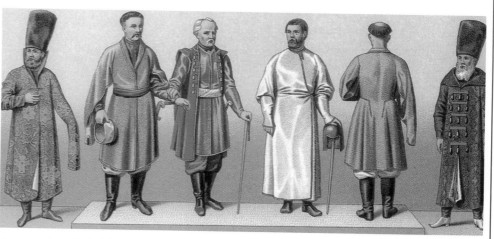

A range of men's fashions from Eastern Europe from the seventeenth and eighteenth centuries.

The Fur Trade

Russian territorial expansion was driven largely by the "fur rush" (1742–c. 1782), the desire to acquire furs for use and sale abroad. Russians colonized Siberia from the late sixteenth century, seeking gems and the furs of squirrel, fox, beaver, and, most importantly, sable (a small marten-like animal). The sables were used in Russia and also sold to Europe. In the eighteenth century, the furs of sea otters and seals drove further expansion into Alaska. Many of the local inhabitants, the Aleuts, were forced into slavery, trapping and hunting sea otters and seals for the Russians. Sea otter fur was prized in China, and most pelts were exported in exchange for silk and tea. Alaska remained Russian until it was sold to the United States in 1867.

Russian Court and Country

The Russian court followed Parisian fashions, often quite extravagantly. The empress Elizabeth is said to have left 15,000 gowns at her death, and never to have worn any more than once. She also had a collection of thousands of pairs of shoes and slippers, and had silk stockings sent to her from France.

Western styles had been forced on the nobility by Tsar Peter the Great after an extended visit to Europe in 1698. Peter decreed that long coats be cut off at the knee. He demanded that all men cut their beards off or pay a beard tax.

In contrast with the extravagance of the court, ordinary people in Russia wore the same type of clothes throughout the eighteenth century, though with a lot of regional variations. In the steppes (areas of grassland with hot summers and cold winters), men wore a simple, loose shirt and wide trousers, tucked into boots. Over this they wore a caftan, a narrow coat with long sleeves, which was crossed over at the front and tied with a sash or *turlup*. Over this they could wear an overcoat called a *ferez*, which often had long sleeves, but usually no collar or belt.

Women wore a long, wide gown, belted at the waist, and a diadem headdress with an attached veil. All of the clothes were brightly colored and decorated with embroidery. In winter, the peasants who lived in the country wore very thick stockings and many layers of clothes to keep warm.

Russian women in voluminous gowns and tall headdresses with a flowing veil. The married women wear their hair tied back, while the unmarried woman on the far right wears hers in a braid down her back.

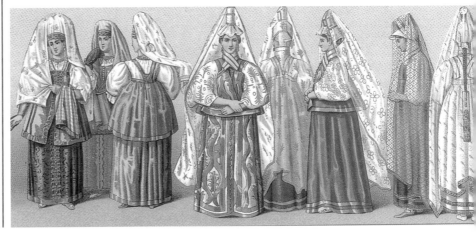

The Middle East

The basic costume worn in much of the Middle East and North Africa was strongly influenced by Muslim tradition. For both men and women it consisted of a long shirt and wide trousers, gathered or tied at the ankles. These were often worn with some type of coat or dress.

Men's Clothing

Men wore a long-sleeved shirt, which was often striped or patterned, and fell to the knees or mid-calf. Over the shirt, men in the Ottoman Empire (now Turkey and the Balkan states) wore a red or blue waistcoat with contrasting braid and small buttons placed close together.

A caftan was worn in most parts of the Middle East. This was a loose coat, open at the front, buttoned at the chest or closed with a scarf. It could be trimmed with fur. In some places, the long skirts were turned back and attached to the belt. For warmth, a long camel-hair cloak called an *abayah* was thrown over the shoulder. It sometimes had a single, wide sleeve. Shoes were red leather slippers or boots with turned-up toes.

In many places, men wore the traditional Turkish fez, a hat with a truncated, conical shape made of red felt, sometimes with fabric wrapped around it like a turban. In Persia (present-day Iran) the hat was of lambskin but it had the same shape.

Working men often wore a simple form of short trousers, a turban, and slippers. They might wear a sleeveless tunic, or go bare chested.

Women's Clothing

Women often wore a long cotton chemise with their wide trousers and embroidered slippers. There was much regional variation in what was worn over this. In some places it was an under-waistcoat with long sleeves open to the elbows and then a short-sleeved over-waistcoat. In others, people wore an ornamented short jacket with long sleeves, or a long robe, often open at the front.

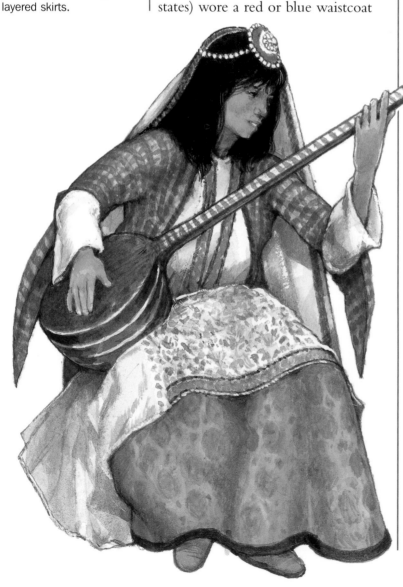

A Turkish woman wearing a short jacket over her chemise, and flowing, layered skirts.

Women kept their heads covered, their headdresses varying greatly from one region and group to another. Most wore a veil either of white muslin or of black silk or horsehair. In some places, when outdoors, women were completely covered by a burka, a tent-like garment with a visor or veil over the eyes.

North Africa

Nomadic peoples in the desert regions of North Africa were usually well covered. The Bedouin wore flowing robes of brown or black cloth, often embroidered in bright reds and oranges. A short jacket of dark wool called a *jubbe* was worn over the robe. They wore a headdress made of two squares of fabric; one

The Tantour

The tantour was an ornate headdress worn by women in Lebanon, possibly from early times until the early nineteenth century. Worn only by married noblewomen, it was a cone made of gold or silver and was up to 30 inches (76 cm) tall. It was engraved and encrusted with diamonds, pearls, and other precious gems. Holes drilled at the base of the tantour allowed ribbons to tie it to the head. A scarf was wound around the base, and a white veil floated from the peak. It was rarely removed, even for sleep.

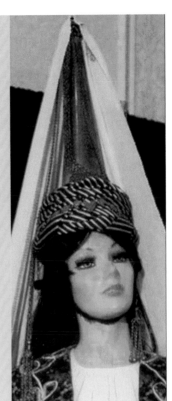

was draped over the head and the other wound around the head to keep the first in place.

In many other parts of Africa, few clothes were worn. The men of the Chir, from the Upper Nile, wore only a loincloth of fig leaves and a cotton cap. Bazy men, also from the Nile area, wore no clothes, but covered their bodies with yellow ocher.

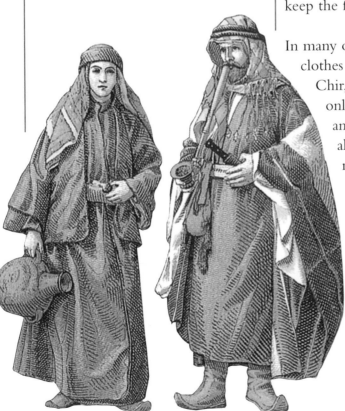

Bedouin man and woman. Red slippers or boots with turned up toes were worn in many parts of North Africa.

India

Despite regional and religious variations, fashions changed slowly in India. Since the efforts of Emperor Akbar (1556–1605) to encourage Hindus and Muslims to live peacefully together, there was a less clear division between Muslim and Hindu dress.

Menswear

Men usually wore a coat or tunic, called a *jamah* or *angarkha* depending on the style, with trousers called *payjamahs*. Some people might also wear a *farji*, a long waistcoat, usually without sleeves, that was worn open at the front.

Trousers were originally close-fitting at the ankle, wide at the top, and gathered in at the waist. During the eighteenth and early nineteenth centuries, the leg of the trousers

Variations on men's costume in India. The trousers can be seen through the transparent muslin skirt of the coat.

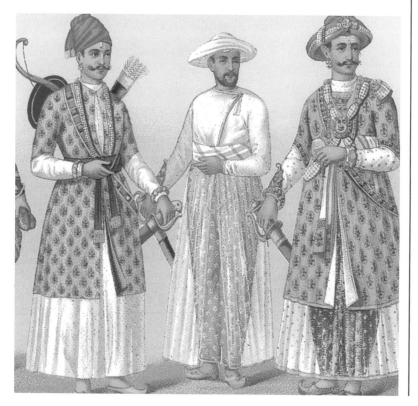

became wider and looser at the bottom. Many Hindu men wore, instead, a dhoti, an unstitched length of cloth that was draped around the lower part of the body.

The coat was close-fitting at the top of the body and had a wide, pleated skirt which at the end of the seventeenth century came to just below the knees. During the early eighteenth century it became longer, reaching almost to the ground in some cases. The seam at the waist rose up the body, too, so that the skirt might start just below the arms.

The coat could be fastened at the neck and waist but with an open slit in between, or have a front flap folded over and fastened, the whole being closed to the neck. It was finished with a sash at the waist. Princes are often seen in portraits wearing a nearly transparent coat which was made of very fine, white muslin.

All men wore a turban, a length of cotton or silk that was wound around the head. Exactly how it was worn indicated the man's social and religious standing, as well as where he came from. For example, the wealthy often wore ornate, decorated turbans made of silk, while an old, poor person usually wore a simple turban of plain white cotton.

Women's Clothes

Hindu women had worn saris for centuries, but from the early nineteenth century onward, Muslim

Symbolic Colors

The colors of Indian clothes were often very rich and vibrant. Many of the colors had meanings in Indian symbolism. The red dye used (madder) enters fibers deeply and was taken to represent the love of Krishna and Radha, so it was usually worn by Hindu brides. Gold and silver together represented the joining of the rivers Ganges and Jumna, or the sun and moon. Violet represented the fruit of the jamon tree, which in turn stood for the holy Hindu scriptures.

women began to adopt them, too. The sari is a piece of decorated fabric up to twenty-seven feet (8.2 m) long and about four feet (1.2 m) wide that is folded, wrapped, and draped over the body. The fullest part is worn around the hips, falling to the ground, and the last part is taken up over the shoulder or head. The precise arrangement of the sari varied between regions and social groups.

The sari was worn with a short jacket called a *choli*. This had short sleeves and stopped above the waist, leaving the midriff bare above the top edge of the sari.

Muslim women usually wore a choli with an open-fronted, pleated skirt called a *ghagra*. A panel like an apron covered the front opening, but was often later replaced with a sari. Alternatively, women wore costumes similar to those of men, with payjamahs or dhoti and a coat. Their arms were often bare from the elbow, where the sleeves of the choli or coat ended.

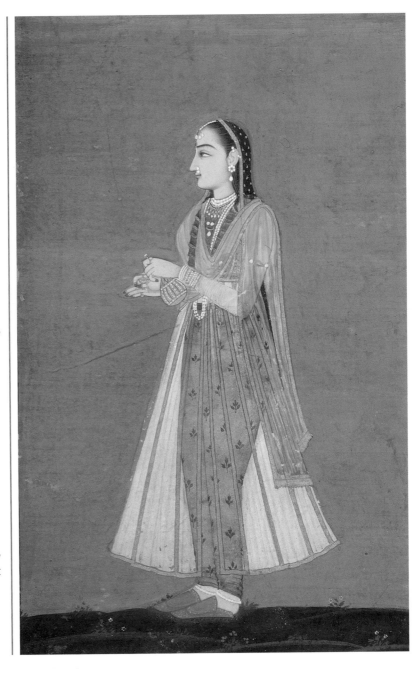

A Muslim woman wearing payjamahs and a transparent muslin coat.

China

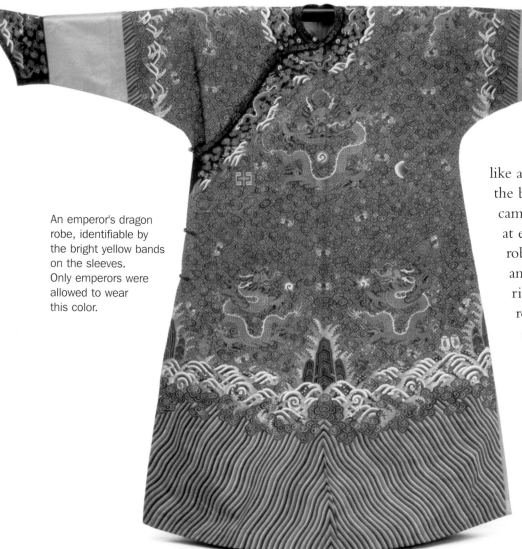

An emperor's dragon robe, identifiable by the bright yellow bands on the sleeves. Only emperors were allowed to wear this color.

The ornate clothes worn in the Chinese imperial court of the eighteenth century were strictly controlled, with colors and emblems used to show the wearer's rank.

Dragon Robes

Normal court wear, called dragon robes, or *qi fu*, were straight-cut robes with a close-fitting neckband. They had an overlapping flap on the right, and fastened at the neck, along the flap, and under the arm. Tubular sleeves ended in a long cuff shaped like a horse's hoof that covered the back of the hand. The skirt came to the ankles and was slit at each side. For men, the robe was also slit in the back and the front for horse riding. In other respects, the robe was the same for men and women.

High-ranking members of the court wore robes decorated with nine dragons—eight visible and one hidden on the inner flap. For lower ranks, the hidden dragon was missing. The design of the robes was symbolic, with the earth represented at the bottom by waves and mountains, then the sky by clouds and dragons. The spiritual realm was represented by the wearer's head.

The robe was worn with a silk girdle with hanging purses and a knife case, as well as a hat, boots, and necklaces. Women wore a dragon coat over the robe in public. This was a full-length, wide-sleeved surcoat that opened down the front and was made in blue-black silk with dragons in roundels.

Ceremonial Wear

A slightly different robe, called *chao fu*, was worn for great feasts and sacrifices. It had narrow sleeves ending in "horse-hoof" cuffs and a full, pleated skirt attached at the waistband. A close-fitting neckband had a detachable collar with tips like wings that extended over the shoulders.

Only the highest-ranking women wore chao fu. The woman's robe was cut straight and long with no change at the waist. It had a cape-like collar with flaring epaulets which narrowed to points and went beneath the arms.

Outerwear

Over other robes, a three-quarter-length coat of plain purple-black silk gave a clearer indication of rank, with symbols arranged in panels called mandarin squares. The emperor's family had arrangements of five-clawed dragons; nobles had four-clawed dragons and mythical beasts; the nine orders of mandarin (official) wore bird and animal motifs.

Fabrics

The Chinese have been using silk for up to seven thousand years and used it for all court dress. In winter, robes were of heavy silk satin, with embroidered or woven patterns. They were quilted or lined with fur for warmth. In the summer, very light silk gauze or damask was used, lined with lightweight figured silk.

Sumptuary Laws of 1759

Sumptuary laws restrict or dictate the clothing people may wear. In 1759 Emperor Qianlong drew up a set of regulations that determined the costumes to be worn in the court by the imperial family, nobility, and mandarins.

The colors and decorations worn by people of different ranks were strictly controlled. Only the emperor could wear bright yellow; members of the imperial family wore shades of yellow, and the nobility wore blue. The arrangement of dragons, waves, mountains, clouds, and Taoist or Buddhist symbols on robes was strictly laid down.

The emperor switched from summer to winter robes, or vice versa, on an appointed day at a set hour, and everyone at court had to follow at the same time or face a severe punishment.

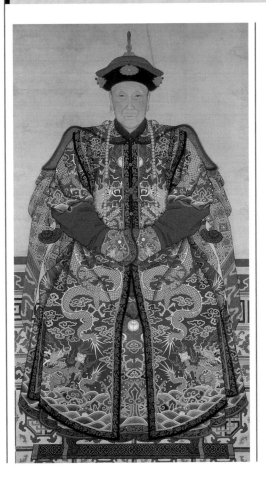

The wife of a court official wearing clothes decorated with the four-clawed dragons appropriate to her rank.

Around the Pacific

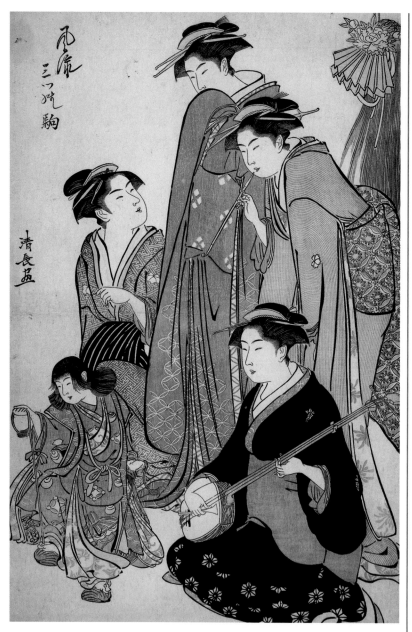

Women of the Edo period, wearing kimonos and obis, watch as a young girl dances.

Some of the countries around the Pacific were being explored for the first time by Westerners in the second half of the eighteenth century. Members of Captain Cook's expeditions, between 1769 and 1779, observed the lifestyles of peoples in Polynesia and many of the small groups of islands in the Pacific Ocean. At the same time, Japan remained largely closed to the West, but South America had been extensively colonized by the Spanish and Portuguese from the sixteenth century onward.

Japan

The main formal and court garment for Japanese men and women was the kimono. The Edo period (1605–1867) saw a narrow kimono with the obi, or waist sash, tied at the back. The kimono was worn over a top and wraparound skirt and an under-kimono.

A new dyeing process, called yuzen, allowed hand-painted designs to be transferred onto silk for the first time. Brightly colored, highly decorative designs became very popular.

Sarongs from Indonesia

The traditional garment in Java, for men and women, was the sarong, a rectangular length of cotton or silk around forty-five by seventy-five inches (115 by 190 cm) that was wrapped around the body. Sarongs were printed using a dye-resist technique called batik. A design is painted or stamped onto the fabric with wax, rice paste, or mud, and the fabric is then dyed. The areas covered by wax, paste, or mud are not colored, because the substance resists the dye. The wax is removed by immersing the fabric in very hot water.

Most people wore shirts, trousers or leggings, and stockings, all of cotton. Over this they would wear one or more cotton robes. Women often wore a red silk tunic in place of a shirt. Poorer people made shirts by weaving strips of bark from the atooshi tree.

The Pacific Islands and Australia

Inhabitants of the many islands in the Pacific wore a wide range of clothing. In New Guinea and the surrounding islands, people wore little more than skirts made of plant fibers and often ornate headdresses for battle or ceremonies. In Indonesia, silks and cottons imported from India were worn as skirts and wide trousers. In Borneo, warriors wore a loincloth and a protective breastplate made of fish skin. The aborigines in Australia wore simple loincloths and capes made of plant fibers or animal skins.

South America

South America was home to colonists from Europe and the many tribes who lived in the forests and mountains of the interior. Some tribes, which had little or no contact with the colonists, continued to wear their traditional clothing, but others adopted Spanish dress to a greater or lesser degree.

Some tribes wore very few clothes, often just arm or leg bands of fur, decorated with hanging feathers or with shell or bone ornaments. Loincloths were worn by many tribes, usually made of cotton and decorated with beads and seeds.

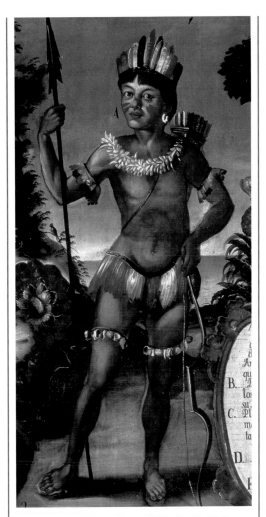

Women commonly wore a simple skirt or apron, again often made of cotton. The women of the De'áruwa tribe made theirs from marima tree bark decorated with seeds.

A common garment in the colder, mountainous regions of Chile was the poncho, a rectangular piece of woolen fabric similar to a blanket with a hole for the head, which reached no further than the knees. Traditional textile design mixed bright colors—usually in geometric patterns such as stripes, zigzags, and squares—that had been used since Aztec and Inca times.

A Yumbo Indian from Quito in Ecuador. He wears bands made from fur and feathers around his arms and legs.

A man from Chile wearing a woolen poncho.

Native North Americans

There were many indigenous races and tribes in North America in the eighteenth century. Some had no contact with settlers, and few items of their clothing have survived, so little is known of it. Other tribes were of great interest to American colonists and Europeans, and their clothing has been well documented.

Regional Variation

The use of clothing by Native Americans varied widely. In some places, men went naked most of the time, but in others tribal identity, age, and gender were shown in the design of moccasins (soft shoes) and of beadwork, the cut of garments, and the type of headdress worn.

Fine beadwork was often used to embellish simple garments.

Typical Garments

In many places, men wore a simple breechcloth, usually a rectangular piece of hide or fabric that hung from the waist, front, and back. They might also wear leggings or simple trousers, and perhaps a tunic. Women never went naked. They often wore either a tunic fastened at one or both shoulders, or a skirt. Often the edges of a tunic, skirt, or dress would be fringed. In cold weather, both men and women used a cloak or a blanket, and some tribes also had hats or hoods. Many tribes wore moccasins, soft leather shoes cut in either one or two pieces. Others went barefoot or made simple sandals from grass or bark.

Materials

Most North American native clothing was made from the cured leather of deer, buffalo, caribou, or elk. Some tribes even used bird and fish skins. Fur came from bears, rabbits, squirrels, marmosets, beaver, or mink.

Although they had no woven fabrics, some tribes made clothes from plant products. Men in California and the northwest made capes and hats for wet weather from shredded cedar bark or other plant fibers. Tule grass was used for skirts and sandals. Many tribes made ceremonial capes, skirts, or tunics from a network of hemp or grass fibers onto which they hung feathers.

Decoration

Some tribes decorated their clothes with embroidery, some with painting and dyeing, and others with quillwork made by stitching designs in porcupine quill. Quills were moistened to soften them, sometimes dyed, flattened with teeth, and then stitched in place. Ornamental objects such as shells, bones, bird beaks, teeth, and claws were often stitched to ceremonial garments or used in jewelry. The scalps from colorful birds such as woodpeckers and mallards were sometimes stitched to capes.

Manufacture of Clothes

Their garments were usually tied or stitched with animal sinews or sometimes with plant fibers. Many Native American tribes had no

Magical Costumes

Many tribes had shamans who carried out rituals to bring rain, successful hunting, or a good harvest. They often wore unusual and extravagant costumes to increase or emphasize their power.

The Iroquois wore grotesque, twisted face masks in curing rites. These were carved from living trees to capture the spirit of a natural god. Others wore feathers from powerful birds, such as golden eagles, or teeth from grizzly bears, hoping to share the powers of the animal.

Other magical items included amulets that incorporated the wearer's umbilical cord, thought by the Sioux to ensure long life. When one of the Shasta of California died, their hair was woven into a mourning belt.

needles, but dried sinews at the end to form a point. Holes were made in the leather with a bone awl or thorn, and the sharp end of the sinew could easily be pushed through. Others sometimes used bone needles, or metal needles traded with Westerners.

An Iroquois mask, used in ceremonial dances.

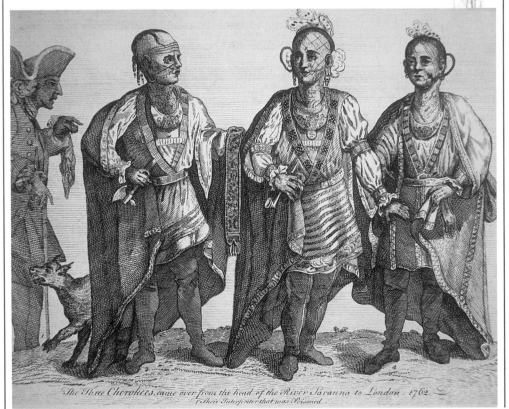

The Three Cherokees, came over from the head of the River Savanna to London 1762 & their Interpreter that was Poisoned.

Three Cherokee Indians who visited London in 1762. In their dress, they mix traditional Cherokee items with cloth shirts and silver necklaces from European contacts.

The Arctic

In temperate climates, most people wore similar clothes in summer and winter, adding a coat, cloak, or blanket if the weather was particularly cold or wet. Some parts of the world, though, have extreme weather. The Eskimos (or Inuit and Yupic) live in the most extreme climates in the Arctic and sub-Arctic regions, where the winter is long and very cold and the summer is a brief period of permanent daylight.

A hunter of the Caribou Eskimo group, near Hudson Bay.

Eskimos

Eskimos are a single race of people who live all around the northern regions of the world, in Canada, Siberia, northern Scandinavia, and Greenland. Their clothing varied by region. Some groups had had contact with the West by the end of the eighteenth century and so began to adopt some materials and styles not native to them.

Decoration

Some groups decorated their clothes, either embroidering them with moose or reindeer hair, adding a patchwork of different-colored fur, or dyeing or painting them. Special costumes often had decorations of bone or teeth, feathers, and shells. The shaman and dancers of the Chilkat of Alaska wore a ceremonial deerskin apron adorned with deer claws, puffin beaks, and quillwork. On their heads they wore a crown of grizzly bear claws or a pair of mountain goat horns on a leather band.

Materials

The regions where Eskimos lived had few plants that could be used to make clothing, and almost all of their garments were made from animal skins. Sealskin was widely used, but other skins—including polar bear, reindeer, dog, caribou, moose, and even fish, bird, or whale skin—was used in some places. Seal hunters from Alaska, taken into slavery by Russia, wore semitransparent, waterproof shirts made from the intestines of sea animals, and used the insides of seal gullets for leggings and boots.

Typical Clothing

In most places, both men and women wore an anorak, a warm, waterproof coat with a long tail at the back to make sitting on the snow more comfortable. The anorak was made of sealskin in most places, but the people of Baffin Island, near the Bering Straits, made theirs from dried strips of seal or walrus intestine stitched together with sinew, and often decorated with cormorant or auklet feathers.

Women of some groups would carry a small child in a large anorak hood, held safe by a harness attached to a large button or toggle at the front of the anorak.

With the anorak, the Eskimo wore thick trousers, usually made of sealskin and always tucked into the boots. Sealskin was usually worn with the fur on the inside, and for boots it

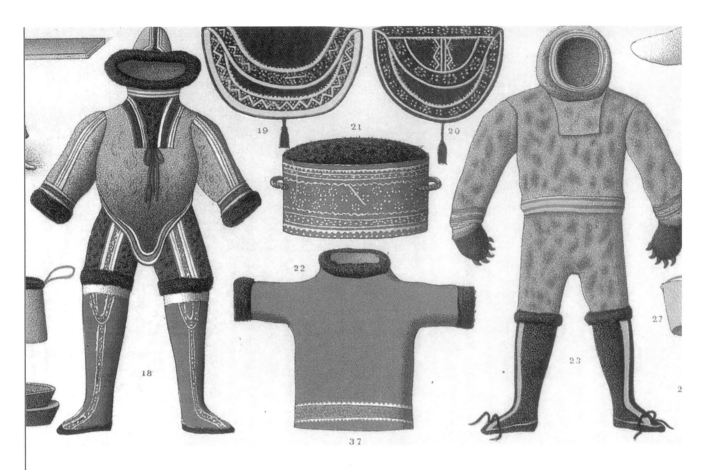

was drenched with oil to make it waterproof. Socks could be made from woven grass. The outer trousers were removed indoors, revealing a pair of short pants made of caribou calf skin.

Keeping the hands warm and dry while working with snow and freezing water was vital. In southwest Alaska, some people wore inner mittens made of woven grass, and outer mittens made of fish skin. Others wore mittens made of squirrel, wolverine, polar bear, or caribou fur. In Greenland, sealskin mittens had two thumbs so that they could be turned around when the palm became too wet. Whale hunters

in Greenland had anorak, trousers, mittens, and boots attached in a single garment to keep out the freezing water.

Above: On the left, a woman's costume made from sealskin and lined with fur. On the right, the man's sealskin outfit has gloves made from a bear's paws, with the claws still attached.

Left: This Eskimo child wears a miniature version of her mother's clothing.

Chapter 3: Functional Fashions

The high fashions discussed in the first chapter were worn by wealthy people in Europe and America—people who generally led a leisured life and did no strenuous manual work. For everybody else, everyday dress had to allow them the freedom of movement they needed for their activities, as well as being hardwearing and affordable. This chapter will look at the clothes people wore for different types of activity—for work, travel, battle, special occasions, and religious activity.

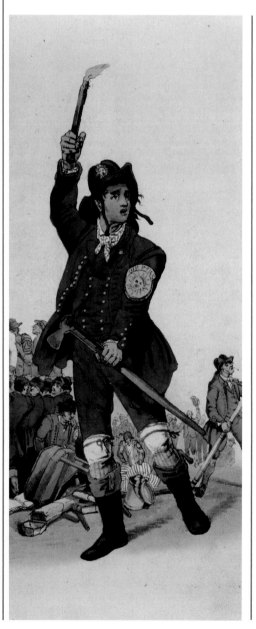

An English fireman, from around 1800.

Work Clothes

Everyday Work Wear

For many people, work dress needed only to provide warmth and protection. Their clothes had to be robust and practical, with no sweeping skirts or coattails that might become trapped or torn.

Working Men

Most working men in Europe wore breeches with stockings, a shirt, a waistcoat, and a jacket or coat. The fabrics were often coarse linen or wool and there was little or no adornment. Many working people continued to wear breeches long after trousers replaced them in fashionable dress, though sailors and laborers had worn trousers before they became fashionable.

Men in a wide range of occupations wore aprons, including carpenters, butchers, masons, and bakers. The fabric was suited to the particular activity, so a baker would wear a cloth apron, but a blacksmith wore leather. Many men wore folded,

Secondhand Clothes

Secondhand clothes were an important part of the clothing trade in the fashionable capitals of Europe. Good quality, fashionable clothes were very expensive, and many people aspired to wear finer clothes than they could afford, so there was a vigorous trade in secondhand garments. Many servants were given cast-off clothes by their employers, which added to the impression that servants were well dressed. Because the trade in secondhand clothes was lively, clothes and cloth were often stolen—they were easy to move, they could easily be resold, and were difficult to trace.

square paper hats of a type worn to this day by some people working in food production.

Daniel Defoe, writing in the mid-1720s, describes men working in lead mines wearing clothes made entirely of leather, with a brimless leather hat. Later illustrations show coal miners wearing flannel trousers and a shirt and waistcoat, often in impractical colors such as white, blue, or red. Women and children worked in the mines, too. Records from the early nineteenth century suggest that miners often worked naked, or in only ragged trousers or a shift.

The slave child wears extravagant clothing with a turban added to make him look exotic. Many slaves wore a metal neckband with their owner's details.

Working Women

Many women worked in domestic service as maids, cooks, and cleaners. In the country they wore skirts without paniers or hoops, often bunched up at the back to protect them, and covered with an apron. They wore a mobcap, or "limp hood," an indoor cap with a high, full crown and often tied under the chin.

In town, women in service were more fashionably dressed. There were complaints that they became so

preoccupied with fashion that they would not work properly for fear of spoiling their clothes. Many wore a linen or calico dress, bunched in the polonaise style, with a long, white apron and a muslin kerchief over their shoulders and chest. The skirt often stopped at the ankle to allow movement. When waistlines rose for fashionable women, so did those of their servants, so that their aprons were tied just below the bust.

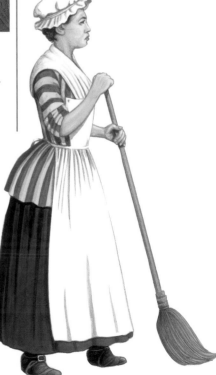

An American housemaid.

Seafaring and Traveling

Traveling, especially by sea, was difficult and often dangerous in the eighteenth century. Clothing for travel had to be warm and hard wearing.

Sailors

Sailors wore either their own clothing or garments bought from the "slop chest," the supplies carried by the ship. There was no naval uniform in the early eighteenth century, though a blue jacket was introduced for officers in the British navy in 1748, and the American navy introduced a full uniform in 1776.

On deck, sailors on large ships usually wore loose-cut trousers in blue, red, white, or stripes, with a serge, duck, or flannel shirt worn open at the neck. The shirt was usually green or red and often checked, and had a low, unstarched collar. Over this, seamen wore a long waistcoat, often in yellow or red. Their trousers were held up with a knife belt or black kerchief, and they wore a knotted kerchief around their necks. They wore thick woolen stockings with flat, black shoes and a cap of fur or wool. For protection against bad weather, the sailor could wear a long apron of oiled canvas and a heavy outer coat.

On land, sailors had to dress smartly. They often wore a short jacket buttoned on the right; long, wide trousers; and a shirt in blue and white stripes, or plain blue, white, or red. Because of the hard life at sea, clothes did not last long. Sailors whose clothes became ragged could buy new clothes on credit from the slop chest. They carried needles and thread to mend their clothes and many also seem to have decorated them, adding ribbons, *appliqué,* and embroidery. If a sailor died, his clothing was immediately auctioned on deck.

Riding

For many people, the most common form of transport was riding on horseback. For the wealthier classes in England and France, riding was also a sport—a spectator sport in the

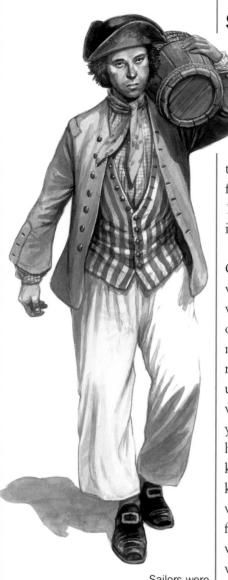

Sailors were one of the earliest groups to wear trousers.

Cloaks and Coats

Although cloaks and capes had gone out of fashion for many occasions, they were still worn for traveling. When people traveled on horseback or in drafty coaches, a cloak was a useful way of keeping warm. Traveling cloaks were wide and long and were worn wrapped around the body. They were usually lined and made of thick, woolen fabric. Overcoats were also worn, often with a short cape attached at the shoulders. In America particularly, the overcoat was more popular than the cape. It was usually long and not fitted at the waist. Stagecoach drivers always wore this box-shaped coat with a cape at the shoulders.

People wearing practical clothing for a trip in a hot-air balloon in 1785.

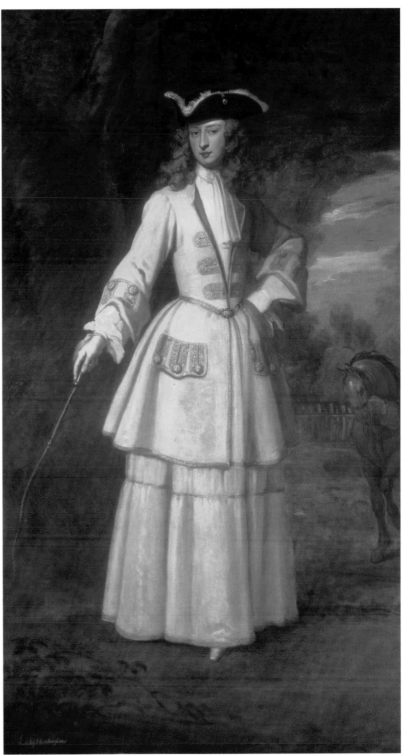

case of horse racing, or one in which they participated in the case of hunting.

The move to a tailcoat for men in European fashion was driven by the popularity of the English riding costume. The coat was easy to ride in, because there was no long skirt at the front to get in the way, and the divided tails could fall on either side of the horse. Even the earlier *justaucorps* was pleated and split at the backs and sides so that it fell easily over the back of a horse.

Women's riding gear produced the fashionable redingote style of dress. Much plainer than the very ornate French styles, this was well suited to movement and the outdoors and could be made in warm fabrics.

Women's riding costumes borrowed from men's fashions. The hairstyle, hat and coat in this portrait all recall men's fashions of the early eighteenth century.

American Puritanism and Plain Dressing

While many Americans followed European fashions with enthusiasm, a large, puritanical group shunned their excessive decoration. Collectively know as plain people, the group included the Quakers, Pietists or Brethren, Mennonites, and Amish.

Quakers

The largest group embracing plain dress were the Quakers, centered in Philadelphia, the capital of William Penn's Quaker colony. The Quakers dominated the city for the entire eighteenth century.

Although their clothes were completely unadorned, with no embroidery, brocade, jewels, colored facings, or braid, many Quakers were very wealthy and the fabrics they used were often of fine quality.

In rejecting the excesses of fashion, the Quakers and other groups found their own styles of plain dressing. No patterns were allowed, but "changeable" silks and worsted wools, with the warp one color and the weft another, were very popular. They commonly wore muted, but not necessarily drab, colors. Their caps, shirts, aprons, and stockings were white. Men wore a simple, white linen stock at the neck.

The cut of Quakers' clothing was the same as that worn by fashionable people, though usually several years behind fashion. Linen was used for shirts, sometimes edged with a very small amount of lace. Quakers tried above all else not to draw attention to themselves, so they avoided ostentatious plainness as well as decoration.

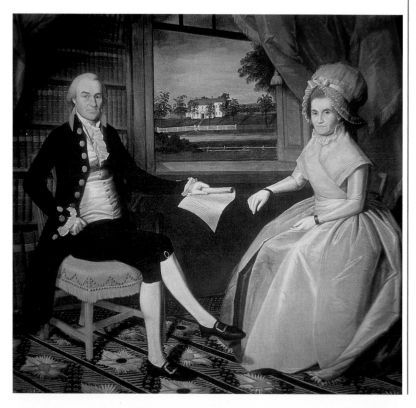

A Quaker couple in good quality plain clothes.

The Amish

The Amish arrived in America and settled around Pennsylvania in the middle and second half of the eighteenth century. Their appearance and mode of dress were more puritanical than those of the Quakers and other plain people. Men wore their beards uncut and women did not cut their hair. Their clothes were homemade from hemp that they spun themselves. There was no adornment or decoration, and all clothes had to be cut to the same approved styles. These styles did not change and were unaffected by fashions in the rest of the world.

Hats and Hair

Quaker men wore their hats at all times, even indoors. These had a wide brim usually left straight, though some men curved it up at the sides. The hat was covered with black silk. Most wore their own hair, which fell to the shoulders and was rarely powdered. Quaker women wore their hair pinned on top of the head and covered with a cap or bonnet.

White Quakers

A group following the lead of John Woolman (1720–72), known as the white Quakers, wore undyed clothes. Woolman objected to the use of indigo dye because of the involvement of slave labor—as well as the damage caused to the environment—in the production and dyeing processes. After some soul-searching, Woolman chose to forego all colors. The decision was a difficult one because he felt that to dress in uncolored clothes could make him conspicuous: "the apprehension of being looked upon as one affecting singularity felt uneasy to me," he wrote.

Distinctive Dress

Toward the end of the eighteenth century, the Quakers' style of dress became more distinctive. This perhaps occurred because they wanted to distance themselves from other religious groups, and adopting a more uniform dress helped them to forge an identity of their own. The men continued to wear breeches and stockings when more fashionable men had adopted trousers. Both men

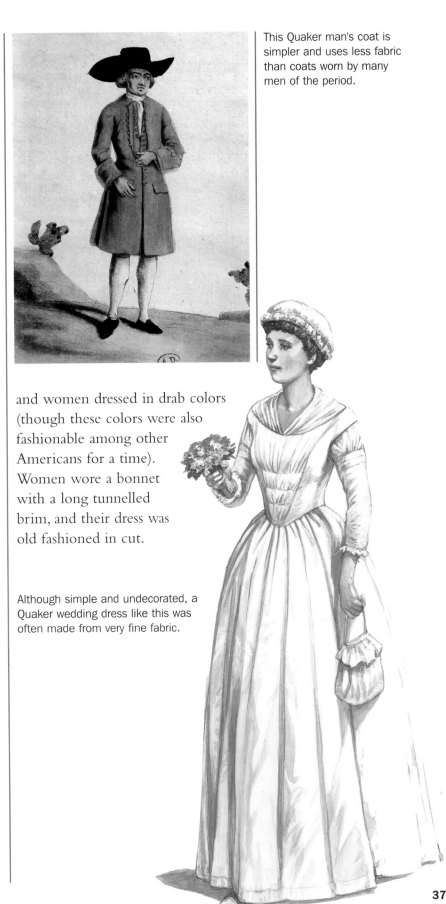

This Quaker man's coat is simpler and uses less fabric than coats worn by many men of the period.

and women dressed in drab colors (though these colors were also fashionable among other Americans for a time). Women wore a bonnet with a long tunnelled brim, and their dress was old fashioned in cut.

Although simple and undecorated, a Quaker wedding dress like this was often made from very fine fabric.

Pioneers

The best-known pioneers were those Americans who set out from the east coast to claim lands and make a new life farther inland. But other pioneers and explorers were making their way into Australia, South America, and the far north during the eighteenth century.

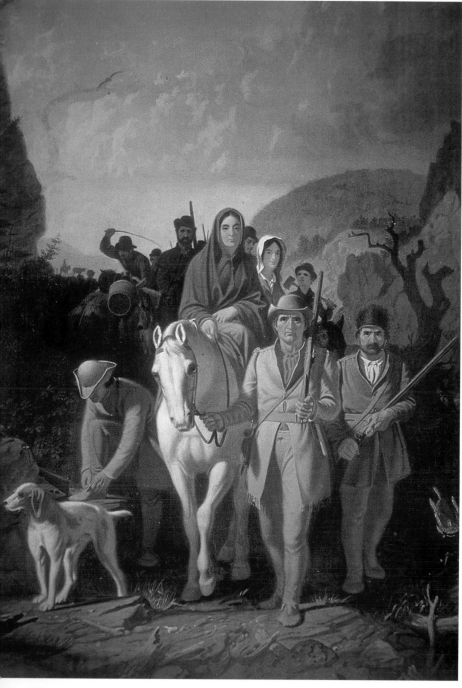

The famous frontiersman Daniel Boone escorting a group of American pioneers in 1775.

Local Clothing

Explorers and pioneers had to carry with them anything that they required for their journey or their new life. This meant there was little space for clothes, and most had to make clothes as they went, or buy from local people.

American Pioneers

The clothing of the American pioneers, like that of the native North Americans, was largely made of buckskin. This was the skin of deer, usually "brain tanned" (treated with a mixture made from the animal's brains during the tanning process). Buckskin was used to make breeches, moccasins, coats, and even shirts. It was suitable for outdoor activity in a wild landscape because it did not get torn on undergrowth and branches, and was waterproof, warm, and flexible.

The Revolutionaries wore buckskin as a sign of patriotism, and George Washington ordered thousands of buckskin shirts and pairs of moccasins for his troops fighting against the English. Buckskin soon became fashionable in Europe, and buckskin breeches were worn by the English upper classes for hunting and riding.

Heading North

In the eighteenth century, explorers renewed their search for a Northwest Passage—a northern route by sea from Europe to the Pacific. The explorers who looked for it needed clothes to confront cold never experienced in Europe or America.

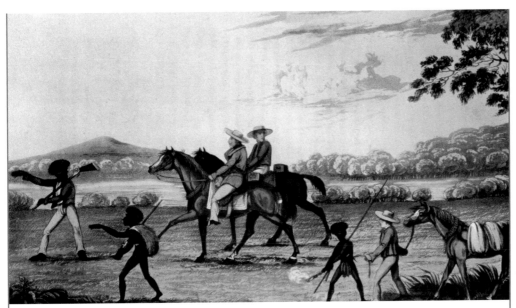

Settlers in New South Wales, Australia. Their wide-brimmed hats protect them from the sun and their trousers and short jackets are suited to riding. Their aboriginal guides wear very little.

Christopher Middleton, who set out from Hudson Bay in 1742, listed the clothes his sailors wore: "a Beaver or Skin tuggy [calf-length coat], above our other Cloaths, Shoes of Deer-Skin, with three or four Socks of thick Blanketting or warm Cloth above our Stockings; Mittens of Beaver lined with Duffield or thick Cloth; and a Beaver Cap with a Chin Cloth which covers the greatest Part of the Face." For crossing the ice and snow, they used snowshoes made from thongs of deer skin.

Australia

Australia was settled by Europeans from 1788 onward. Many of the settlers were either poor or convicts. Wealthier colonists and ex-convicts followed European fashion, and clothing was imported from India and Britain. Colors popular among women were pale brown, olive, and yellow, sometimes called the "drab" style.

The supply of clothes in early Australia was inconsistent; local industry was only just beginning and there was no real currency until 1813. These factors meant that clothing was often in short supply and some people wore their garments until they were ragged.

Australian Convicts

From the 1790s to the 1810s, convicts were issued with "slops"—cheap, ready-made clothing similar to that worn by the working class. They had short jackets, checked frock coats, checked shirts, untwilled cotton trousers, and hats of leather or felt. Women were issued with jackets, skirts, kerchiefs, caps, and hats. Most convicts' clothes were blue or grey. When stocks of clothes ran low, military uniforms were sometimes dyed and passed on to convicts. Those convicts who could afford to do so bought their own clothes.

The government increasingly wanted to distinguish between convicts and free men, and one way of doing this was to make the cut of their clothes different. Convicts wore loose trousers rather than the more fashionable breeches.

Rural Dress

Although many people moved from the countryside to the towns during the eighteenth century, most still lived in the countryside. Their clothing was often coarser and more functional than court or town dress, but in many areas vividly decorated traditional, local costumes were worn.

Farm Labor

Farm workers needed hard-wearing clothes that would protect them from the weather and would not get caught on undergrowth or crops. They were usually very poor and their clothes were basic and often homemade.

In England, men often wore a smock over trousers or breeches. This was a voluminous garment like a dress, with long sleeves and made from coarse linen. It was worn for leisure and work, though the ends were tucked out of the way for some activities. Canvas or leather gaiters fastened around the lower part of the leg.

Women wore open or closed gowns, either made in one piece or with a separate skirt and bodice. In winter, dresses were made of wool or camlot, a fabric made of a wool and hair mix; in summer, light-colored calico or linen was used. The bodice was much longer than that worn in town and was usually left undone from the waist down. It did not always match the skirt. The polonaise style became popular in the countryside around 1800 and remained in fashion for many decades because it was an easy style for work, the skirt being held

An English man's smock with an intricate pattern of stitching (smocking) on the back.

Rural Versailles

The court of Louis XVI in France, centered at Versailles, led European fashion in the latter half of the eighteenth century. The queen, Marie Antoinette, tried to recreate an idyllic rural life there, building a fake and idealized peasant village. She and the ladies at court dressed in what they imagined were peasant costumes, including dresses of fine muslins. Neither the village nor the costumes were anything like those experienced by real peasants.

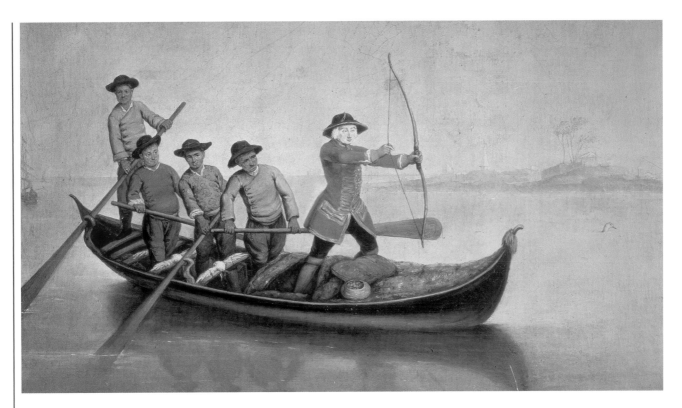

out of the way. A cloak was used for warmth.

For some farm activities, the gown or skirt was removed and the petticoat was pinned up in the style of trousers, leaving the legs bare from the knee. Mining was the only other activity in which women commonly worked without a gown.

Provincial Fashions

There were many variations in regional dress around Europe, with neighboring countries having completely different styles of traditional costume. In central Europe—Germany, Austria, and Switzerland—most women wore full skirts somewhat shorter than those worn elsewhere, with a brightly embroidered, laced bodice and white shirt.

Warmer Climates

In hot countries, many people who worked the land wore no clothes, or very few. A simple loincloth was often worn in India. In China, farmworkers wore a long shirt made of undyed hemp. The nomadic Himba people of southern Africa wore short skirts of animal hide, and red body paint, while the East African Dinka men wore only a belt of beads, color-coded to show their age.

The slaves who worked the sugar and cotton plantations in America often wore only a cotton shirt, or a shirt with a skirt or trousers. Their overseers, who also felt the heat, often managed their plantations wearing a banyan, the dressing gown worn indoors when formal dress was not needed, and a decorated cloth cap worn without a wig.

Duck hunters on the Venetian lagoon. The rowers are wearing waist length close-fitting jackets with a side fastening.

Battle Clothing

Military costumes had to be suited both to the climate and the type of activity soldiers expected to engage in. In many parts of the world, armor was still used. The design had to offer protection and allow freedom of movement.

In the West, armor was no longer worn because it offered no protection against gunshot or cannon. Military uniforms were designed to distinguish between armies and ranks and to allow the soldier enough movement to use his firearms.

An officer in the American army.

Military Uniforms in the West

In Europe and America, military uniform and men's civilian dress evolved in parallel, sometimes one taking the lead and sometimes the other. The change from *justaucorps,* breeches, and a long waistcoat, to tight trousers with a short waistcoat and a coat with the front cut away, was essential to allow soldiers to manipulate a rifle, especially when fitted with a bayonet.

British soldiers began cutting away their coattails during the Seven Years

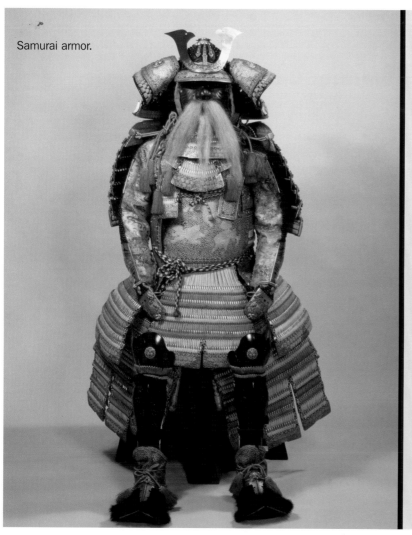

Samurai armor.

Samurai

The Japanese warrior class called the Samurai fought most commonly with swords. The warrior wore armor made of plates of lacquered leather and metal called *kozane*, held together with leather or silk thongs. The main parts of the armor were a breast plate and helmet. There was often also protection for the lower legs and for the lower part of the left arm, and occasionally a short skirt that protected the upper legs. The armor was worn over a short kimono fastened with an obi. From the beginning of the eighteenth century, the samurai wore padded armor made of bamboo and cotton when practicing and training in swordsmanship.

War in America (1756–63), to avoid becoming caught on undergrowth. Short-skirted coats became official wear for the rank and file from 1797, and for officers from 1812. American army officers had a greatcoat or cloak for warmth, but ordinary soldiers managed with a Dutch blanket.

Eastern Battle Costume

Many developed nations, such as Japan, India, and the Ottoman Empire, did not have firearms in the eighteenth century and their soldiers still wore armor, which was often very ornate and even beautiful. Armor could be adorned with jewels or enamelling on the metal, or with embroidery on velvet bands or leather, or painting and gilding on leatherwork.

Much armor was made of jointed plates of leather or metal, or a combination of both. The plates were either held together with thongs or stitched to a cloth backing. Overlapping plates were often used to protect against arrows, which might pierce even small gaps. In some places, chain mail, made of many small, metal links, was still used.

Sikh soldiers in northern India wore a chain-mail shirt with a large metal plate in back and front to protect the chest, metal panels over the lower arms, and a metal helmet. The neck was protected by a chain-mail hood beneath the helmet. Chain mail was much more flexible than plate armor.

Tribal Battle Gear

Many tribes were ingenious in their use of local materials to make protective armor. Native North Americans used wooden slats held together with leather thongs. In Baffin Island, hoops of doubled sealskin were stitched together into a telescopic funnel shape that could be lifted up and tied at the waist for running. In southwest Alaska, plates of bone or walrus ivory were laced together with sinew into an armored vest.

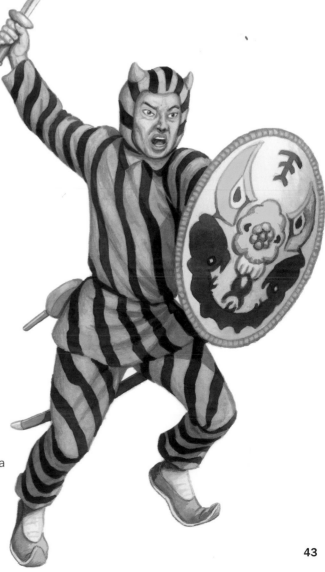

A Chinese Tiger of War. Each formation of soldiers on the battlefield was led by a *ten nai,* or tiger man, dressed in yellow and black stripes and a hood with tiger ears.

Religious Clothing

In most religions, the priests who conduct religious ceremonies wear distinctive costumes. These may be either ornate or very simple. Monks and nuns usually wear clothes designed to encourage humility and avoid pride. Some religions, such as Islam, also have dress codes which control the clothing of ordinary people.

Priests

In the Catholic Church, priests wore ornate, embroidered garments (vestments) for mass. These included a long, close-fitting linen robe called an alb, covered with a chasuble, a kind of sleeveless tunic based on the day-to-day wear of the very early Christians. A cope, or semicircular cape, was also worn on some occasions. The chasuble and cope were both decorated with colored and gold embroidery in designs with symbolic meanings. A large number of other symbolic garments and accessories were also worn. Very similar vestments are worn today.

Protestant Reform churches shunned ornate vestments, and most preachers wore simple robes of black, often with a white surplice and a white stock at the neck.

Japanese Buddhist priests wore a robe called a *kesa*, made up from seven to twenty-five panels stitched into a rectangular patchwork. This was draped under the left arm and fastened by two corners on the right shoulder. Because the priest had taken a vow of poverty, the kesa was made of discarded rags or donated fabrics. However, it was often made of very ornate cloth and could look richly decorated, because donors frequently gave scraps of fine but damaged clothes as offerings. In China, a similar style of robe was often worn. This was frequently beautifully embroidered or made of brocade as a single garment, rather than a patchwork.

Monks and Nuns

Monks and nuns in Europe wore long, simple robes of plain, dull colors, the exact color and style depending on the monastic order. The habit was made of coarse or

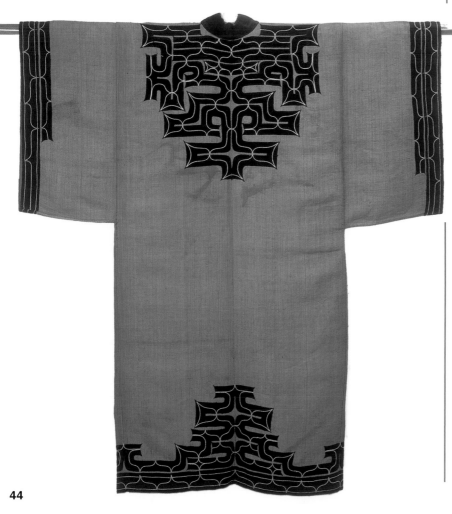

A religious robe made of elm bark fiber, worn by the Ainu aborigine group in Japan.

plain cloth and sometimes had a hood or cowl. Nuns often wore veils over their heads and some covered their faces.

Hindu and Buddhist monks dressed simply, but in clothes that were better adapted to hot weather. Jain monks wore either a white robe and a face mask to prevent them from inhaling insects, or wore nothing at all—the Digambara called themselves "sky-clad" because they were clothed only in the air. Elderly Hindu monks wore tattered orange robes, given or discarded by others.

Religious Codes of Dress

Some religions had codes of dress for everybody, not just those who led ceremonies and religious meetings. The dress worn in most Middle Eastern countries and many parts of North Africa followed the code set

The Gown of Repentance

In Scotland, people condemned as sinners were sometimes punished by being forced to wear a "gown of repentance" in public on Sundays. This was a very coarse, plain T-shaped garment made of sackcloth. It had sleeves that came to the elbow, and was completely unshaped.

Most often, it was women who had committed adultery or had pre-marital sex who were forced to wear it. They had to appear at church, or at the church door, for a stipulated number of weeks. This encouraged a sense of shame.

down in Muslim law. For this reason, men and women all over these areas and in parts of India wore loose trousers and a long shift. Women frequently kept their heads veiled when outdoors.

(See pages 36–37 for information on the dress of the Quakers and Amish.)

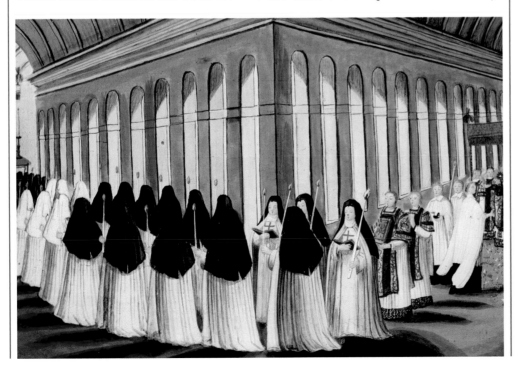

French Benedictine nuns in the abbey of Port-Royale, 1710.

Celebration Wear

People have always dressed in special costumes for celebrations and important occasions. Sometimes, clothes for special events are more ornate, or just clean or new versions of everyday costumes, but sometimes they are completely different.

Europe

Court dress in Europe, and clothes for special occasions in America, followed fashion, but used more elaborate fabrics and decoration. Men's coats and waistcoats, for instance, would be cut from fine brocades, or decorated with intricate embroidery and even precious stones.

In Europe, the extravagant style of wide paniers and decorated dresses continued to be worn for court occasions for several years after these fashions had disappeared from everyday wear.

Stages of Life

Different clothes were often worn for an event that celebrated a transition in life, such as the passage into adulthood or marriage.

Christening marks a child's entry into the Christian community, and ornate christening robes were worn in Europe. George III of England's daughter wore a white satin mantle edged with ermine and adorned with many precious stones.

Wedding Colors

Poorer English brides wore simple dresses—often one they already owned. However, the wealthy had extravagant gowns made, usually in blue, silver, or white, though yellow and gold were also popular. There were many local variations in wedding dress around Europe, especially in rural areas where

A woman's wedding coat made of salmon skin, from the Amur Basin, Russia.

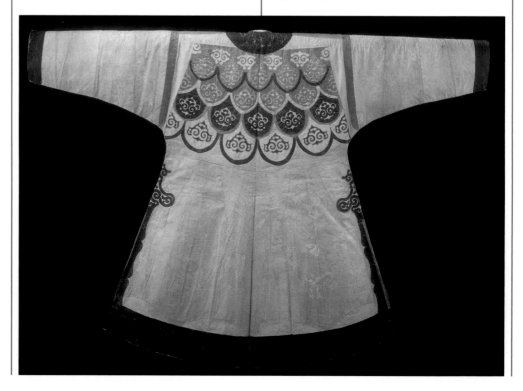

mainstream fashions had little impact. In Athens, brides gilded their faces with gold for the wedding day. In India, China, and many Islamic countries, red was (and is) the traditional color for a bride's clothes.

Funeral and Mourning Garb

Most cultures have special rituals and clothing for funerals, and many have special clothing for a period of mourning after the funeral. White was the color of mourning and was worn for funerals in China and Japan, while black was worn in France, England, and America.

In England, mourners were given a black scarf that was worn diagonally over the left shoulder, a black hat band and gloves, and an engraved ring. Mourners wore black for six weeks or more and then switched to a less rigorous mourning code for a further period.

In Tahiti, an elaborate mourning ceremony was led by a chief mourner in a voluminous costume with a breastplate and mask. The mask was made of turtle and pearl shell, with a fringe of frigate bird feathers. The breastplate was made of pearl shell and was worn with a pearl-shell apron. Beneath, the chief mourner wore many layers of barkcloth tunics dyed red, brown, and yellow. More barkcloth was wrapped around the head and used for a decorated cape. The cords used to hold on the mask and keep the bindings around the head were made

Coronation of Napoleon Bonaparte

Not long after the French Revolution had swept away ornate fashions, Napoleon was crowned emperor of France in a magnificent ceremony in 1804. The robes worn to his coronation were extravagant and beautiful. The women wore fine silk gowns with ornately decorated overgowns of velvet and silk brocades, all richly decorated with embroidery, pearls, and jewels. Male costumes, designed by the painter Jacques Louis David, were cut from gold and silver brocade. Both men and women wore long, decorated velvet capes and jeweled crowns.

of human hair. The costume was used to mark the end of the funerary rites of a highborn islander until around 1810, when Christianity replaced many indigenous rituals.

Chapter 4: Not Just Clothes

Acomplete outfit consists not just of outer clothes but also of underwear, shoes, accessories, and—in some times and places—hats, wigs, veils, or masks. In Europe and America, many additional items made up a complete set of clothes. Elsewhere, where few clothes were worn, body adornment and modification were often more important than extra items of dress.

Masks and Veils

Masks were worn for many reasons in different parts of the world during

A mask used during ceremonies by members of the Mohawk tribe.

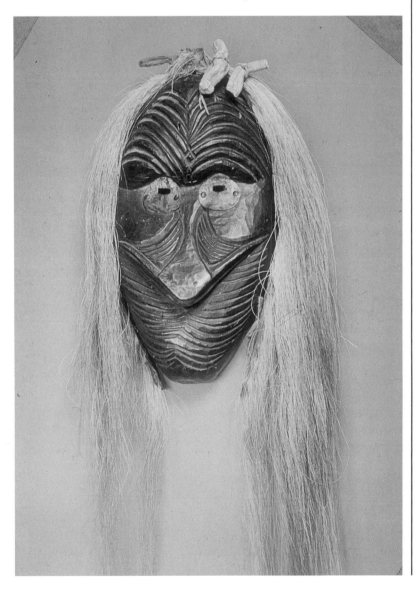

the eighteenth century, as at other times. Some were worn to give anonymity. Others were worn to scare enemies or evil spirits, or to forge a link with an animal or other natural spirit. Veils were frequently worn for modesty, to preserve virtue, or to hide a woman from men's eyes.

Frightening Masks

Warriors from tribes in Africa, North and South America, and some of the Pacific islands often wore frightening masks of human, animal, or monster faces to scare enemies. These were often made of plant products such as bark, wood, or woven leaves or grass stalks, and could be decorated with dyes, feathers, bones, or shells.

Shamans often wore frightening masks to scare away evil spirits. They might also be intended to hide the identity of the man himself, either for protection or to allow better communication with the spirits.

Riding Masks

Women in America wore masks to protect their faces while out riding. In the summer, the mask kept out the heat of the sun; in the winter it offered protection against the cold; and at all times it shielded the woman from the gaze of men. Winter

masks were usually made of black velvet and were held in place by a silver mouthpiece. In summer, green silk was used. Young girls had a white linen mask, held on with ribbons or tapes tied under their hood.

Veils

In many parts of the world, women—particularly unmarried women—wore veils covering either the head or face, or both. Islamic law in many parts of the Middle East and Central Asia required that women keep their faces covered when outdoors. Among Christian women, some nuns kept their faces veiled as a sign of modesty, to avoid lustful looks, and to prevent them from taking pride in their appearance.

Women in India often wore the end of the sari draped over the head in the form of a veil. In parts of Russia, women wore a veil falling from the top of their hat (see page 19). In Spain, women wore a mantilla, a lace veil or shawl worn over the head and shoulders, held up with a decorative comb. In some cultures, a bride wore a veil which was not removed until after the marriage ceremony, when her new husband could look at her face for the first time.

Carnival Masks

Ornate or very plain masks were used at carnivals and celebrations in different places. In Venice, where carnival lasted from December or earlier until Shrove Tuesday, people wore masks to hide their identities while they took part in balls and amused themselves. A black cloak, tricorn hat, and white or black mask could also be worn from October to December and on feast days, so for nearly half the year Venetians could go *in cognito,* enjoying all of the freedoms that anonymity allowed.

Venetian carnival-goers wearing masks.

Undergarments and Nightwear

Here, the woman's underskirt and shift are clearly visible. Her stockings come just to the knee.

In many parts of the world, people wore no underwear, or a simple cloth fastened around the groin under their clothes. In Europe and America, underwear was well developed, especially for women.

The Shift

The basic shift, or chemise, was the principal undergarment for men and women in Europe and America. It was of a simple shape, with long sleeves and either a collar and cuffs or

Rice Straw Vests

Chinese farmers and coolies wore a knitted sleeveless vest made of twisted rice straw fibers. It opened down the front and fastened at the top and the waist with a loop and ball button. Panels of double-thickness hemp or cotton at the back and the shoulders prevented rubbing when the man was carrying a heavy load.

Some Chinese men wore a vest made of tiny pieces of hollow bamboo sewn together in a diamond pattern. This sometimes had sleeves. It was worn in the summer to prevent the shirt or jacket from sticking to the skin. A thin cotton band at the edges prevented the bamboo from cutting into the body. The lower undergarment was a loincloth held in place by a belt.

a drawstring at the neck. It was worn both night and day. Those who could afford it wore a linen shift; others might use cotton, calico, or hemp.

For men, the cuffs and collar were visible beneath their outerwear, and these were frequently decorated with frills and lace. Women's shifts were rarely seen, except perhaps at the neck. During the course of the eighteenth century, the sleeves of women's shifts became shorter. Lace or frills at the cuff of the gown were often attached directly to the gown and no longer formed part of the shift.

Stays

Women—and, occasionally, men—wore stays to shape the upper part of the body. They were made from several layers of stout canvas, cotton, or linen twill, which was stiffened first with paste and then with cords, canes, or whalebone to mold the shape. Stays were worn over the shift, fastened with laces at the back, and sometimes also at the front. People who were especially large, or pregnant, had side laces. Help from a maid, family member, or valet was essential in putting on and lacing up stays. Among the upper classes, even children wore stays, because it was thought to improve their posture and encourage their bodies to grow straight.

Petticoats

Petticoat, in the eighteenth century, meant a skirt that was worn beneath an open skirt or gown and was visible at the front. Petticoats as underwear, or underskirts, came to the knee or mid-calf and were usually made of cotton or linen. They were worn over the shift. This petticoat did not show and was not usually decorated. For warmth, and to help support wide skirts, women wore quilted underskirts. These were made from two layers of silk with a layer of wool in between. Poorer women could only afford flannel underskirts. Under the shift dresses of the late eighteenth century, a full-length undergarment of fine cotton or flesh-colored stockinette was sometimes worn.

Drawers

Drawers were not common for women before 1830, but men wore them throughout the eighteenth century. They were made from two tubes of fabric, stitched onto a wide waistband, laced at the back and fastened with ties. Some women wore flesh-colored drawers under the more transparent shift dresses, but the *merveilleuses* took the opposite approach, wearing no underwear.

A maid lacing up a woman's stays over her shift.

Footwear

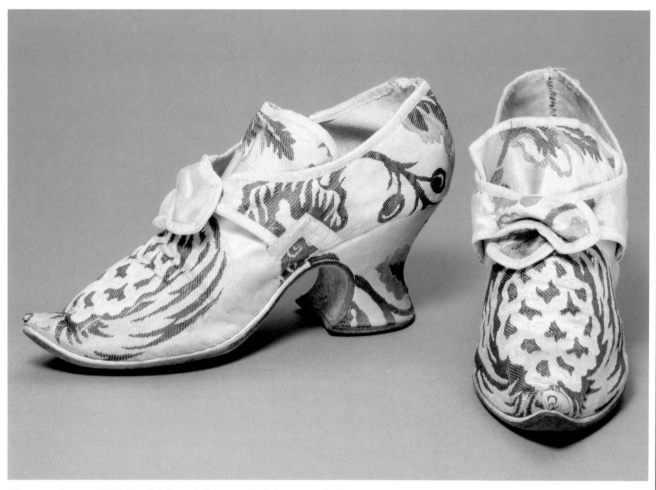

Woman's shoes, 1735. The fabric probably matched the woman's dress.

Foot Binding

In China, most well-off women had bound feet. This practice had already been going on for hundreds of years. When a girl was between three and five years old, her feet would be bound so that they would remain small. Binding involved bending the toes under the foot toward the heel and binding them tightly with a binding cloth so that the toes were broken and the foot grew as a deformed hook. The ideal size of adult women's feet was five inches (13 cm), or three Chinese inches. Walking was difficult and extremely painful. Women kept their bound feet covered at all times, even wearing special red silk slippers in bed, often with bells in the toes. During the day they wore bindings, socks, and beautifully embroidered silk shoes.

In Europe and America, fashions in footwear changed radically during the eighteenth century. Elsewhere, however, most footwear was utilitarian—designed to protect the feet from the weather and the ground—and styles changed little. In some hot countries, people wore no shoes.

Fashionable Women's Footwear in Europe

Fashionable women in Europe began the eighteenth century in shoes with heels, often made of leather or covered with fabric to match their dresses. Indoors, they wore slippers or

mules, again with heels and usually matched to their dresses. By the end of the century, the heel had disappeared and shoes were delicate leather slippers suited to the slimmer and more elegant dresses. Some women wore shoes modeled on the Roman buskin, a kind of laced sandal, to go with their classical-style shifts.

Fashionable Men's Footwear

At the start of the century, men wore leather shoes with high heels and buckles. As the century progressed, the buckles became more ornate and larger and could be decorated with precious or semiprecious stones. Fashionable heels were red. In France, red heels were traditionally a sign of nobility.

In the later part of the century, boots became fashionable, both full-length to the knee or short with a pointed front. In the early nineteenth century, trousers were sometimes worn over boots.

Stockings

Both men and women wore stockings. These were made of silk for the wealthy, and wool or cotton for others. Made by hand at the beginning of the century, they were later frame-knitted, a technological advance that enabled the production of fine, shaped stockings and the inclusion of patterns in the design. Striped or even zigzag-patterned stockings were popular at the end of the century. The Macaroni often wore colored silk stockings in pink, yellow, sky blue, and lilac.

Work Wear

For working in the fields and wet places, both men and women wore wooden-soled clogs. Men could also wear heavy leather shoes for work, reinforced with metal in the form of hobnails (nails in the soles) or metal bands that looked similar to a horseshoe. Wooden blocks or metal supports called pattens could be strapped onto the bottom of ordinary shoes to keep them clear of mud or water.

Two types of patten, designed to keep the wearer's feet out of water or mud.

Outside Europe

A wide range of materials were used for making footwear outside Europe. People living near the Amazon wore simple sandals called *ojatas* with soles of tapir hide and rope loops around the toes. Chinese farmers made sandals from rice straw. Native North Americans and colonial trappers wore moccasins made of the tanned hides of moose or deer. Eskimos wore boots made from sealskin.

Wigs and Hair

In Europe, fashionable people wore wigs throughout much of the eighteenth century, though real hair was in fashion at the end of the century.

Men's Wigs

For the first three quarters of the eighteenth century, men shaved their heads and wore wigs. At the start of the century, the full-bottomed wig was popular. This had curls arranged in peaks on either side of the head and then fell down over the back and shoulders. Wigs were covered with pomatum (a kind of grease) and then with white, grey, or pale blue powder.

Later, wigs became shorter and were often tied back in a pigtail or bag. A frizzy or rolled wig that came to the shoulders, called a bob, was popular with professionals. The smallest were scratch wigs and cut wigs, worn by working people. The dandies of the 1770s wore a style known as the "club" with high rolls at the front of the head and the tail folded and looped back on itself.

A woman's tall hairstyle or wig was often decorated with feathers, jewels, or a small hat balanced on the top.

Real Hair

Wigs finally went out of fashion in England when a tax of a guinea a year (about a week's wage for a tradesman) was imposed for using powder. In the third quarter of the eighteenth century, men often wore a shaggy haircut, sometimes still powdered. Some women wore their hair cropped to the neck for a while, said to have been out of sympathy for the beheaded victims of the guillotine. Later, natural hair was worn in short curls.

Women's Wigs

From around 1760, women's hairstyles started to rise, aided with padding and pomade. During the 1770s, women teased their hair into increasingly extravagant styles built up over a wire framework with the addition of fake hair, wool, and even hay to make it larger. Hair was arranged with a complex collection of jewels, ribbons, lace, feathers, and other decorations—even blown glass horses pulling carriages made of wire! Women kept their styles in

Manufacture of Wigs

The best wigs were made of real human hair. Because this was very expensive, and in limited supply, there were many alternatives. Wigs could be made of horse hair, goat hair, yak hair, silk, or even feathers. Horace Walpole, an English writer and art collector, wrote to a friend about a wire wig he had bought: "you literally would not know it from hair."

A full wig made with real hair could cost as much as thirty or forty pounds (as much as a tailor might earn in nine months). If robbers attacked a man in the street, they were likely to take his wig.

Men's wigs came in a variety of styles.

place for several days and even had special jeweled sticks with which to dislodge vermin from them. The highest European styles were not worn in America.

Hats

For men, the tricorn hat dominated the first three quarters of the eighteenth century. A triangular hat with the brim turned up, adjusted by cords, it was usually decorated with braid and often feathers. Late in the century, a tall beaver hat became popular. This was round, with a tall crown and small brim sometimes rolled toward the crown. It eventually developed into the top hat. Women wore very large hats decorated with feathers, ribbons, and veils in the second half of the

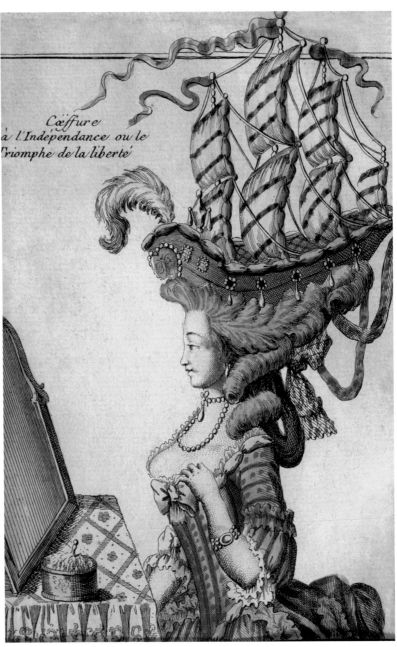

century. To protect the largest hairstyles, they wore voluminous hooded capes outdoors.

Indoors, women usually wore a muslin or lace cap, usually with lappets—hanging bands of fabric or lace that could be tied under the chin or above the head but were often left loose.

Caricaturists made fun of the most flamboyant styles.

Accessories

During the eighteenth century, most accessories had some practical function, but their precise form was dictated by fashion and so sometimes their design detracted from their usefulness.

Umbrellas and Parasols

Ceremonial umbrellas were carried to honor rulers and religious figures in the Far East, India, and even Europe, where ceremonial umbrellas were carried in procession before and after the pope.

Umbrellas were only adopted for practical use in England in the second half of the eighteenth century. Some people scorned them, saying they showed that the owner could not afford a carriage. However, they became very popular—so popular, in fact, that soldiers took them into battle and Wellington complained about their inappropriate use.

While umbrellas were intended to keep the rain off, parasols were for protection from the sun. Parasols were used in France from early in the century, but in Britain and America only from the 1770s onward.

Handbags

Until the late eighteenth century, pockets attached to tapes tied at the waist were worn under the panier and underskirt, reached through slits in the overskirt. Handbags, called reticules, became necessary at the end of the century when dresses had no room for pockets underneath.

Before the reticule appeared, purses were used. These were long bags made of netting that could be carried over the arm, hanging down on either side. Money was kept in each of the hanging sides. There was a slit for putting money into the purse, and a slider to secure it. The weight of the contents kept the double-ended purse in place over the arm.

Mittens and Muffs

As well as gloves to keep the hands warm, people could use mittens or muffs. Mittens are gloves with no fingers. They covered the back of the hand and the palm, but left the fingers free. When worn as a fashion accessory, the flap over the back of the hand could be turned back and was sometimes lined in a contrasting color. Mittens were also worn by working people because they left the fingers free for work.

A muff is a tube of fabric, usually fur, used to keep the hands warm by putting one hand into each open end. Muffs were used by both women and men. They became very

A fur muff and fur-trimmed pelisse.

The Language of Fans

Fans were popular with men and women and came in a wide range of designs. They were often highly decorated and very ornate. Some concealed information the user might want to refer to or perhaps learn, such as the words of a song, a sequence of dance steps, or a calendar of saints' days.

In Europe and America, the way a fan was held or moved could send a message. The language of fans was most fully developed in Spain, where around sixty phrases could be conveyed with a fan, including arranging a time to meet and indicating the passionate intensity of kissing a woman expected.

large between 1730 and 1750, and often had pockets inside. Muffs were made of fur, feathers, or velvet, often scented, and might be hung from a coat button, belt, or from the neck by a ribbon. Pairs of small wrist muffs, called muffettes, were worn in the 1740s.

Canes

Men often carried canes, and many had very ornate handles which sometimes unscrewed to hold scent or a mirror. From the 1730s onward, there was a fashion for very long canes. Until around 1780, men usually wore swords in scabbards, too.

Adornment

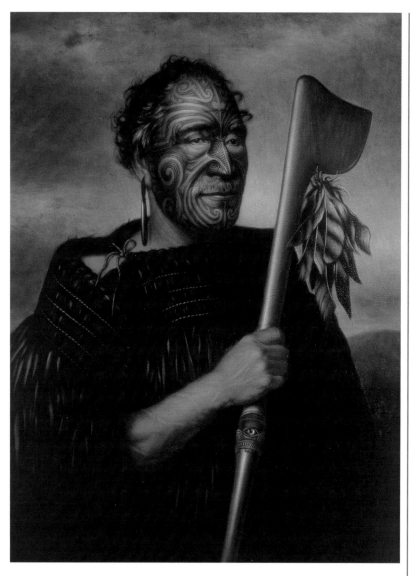
A man from New Zealand, with decorative tattoos.

Costume was often supplemented—or even replaced—by various kinds of body decoration. A richly tattooed or scarred person was often highly respected because they had undergone pain to acquire their decoration.

Body Decoration

Many tribes in South America and the Pacific wore body paint, or decorated their bodies with tattoos. Reddish-brown henna was used to paint intricate designs on the skin in many parts of Africa, the Middle East, and India. Other temporary colors used in many places were ocher (yellow) and kaolin (white), often mixed to a thick mud or clay. The Amazonian tribes in South America painted most of their bodies in black, purple, or blue and added highlights in yellow and red.

Tattooing involves puncturing the skin and drawing a design using plant or mineral coloring in the lower layers of skin where it will be preserved for life. Pacific islanders perfected tattooing in the eighteenth century. The patterns they used and

Criminal Tattoos in Japan

Tattooing replaced amputation of ears and noses as a punishment for Japanese criminals in the eighteenth century, and continued until 1870. For each crime, the criminal received a ring tattoo on one arm, or a character tattoo on the forehead. This practice gave rise to a criminal underclass who were easily identifiable by their tattoos, and who organized themselves into gangs.

Tattoos were also worn by firemen, seen as dashing heroes in Edo-period Japan. It is thought that wealthy merchants, who were barred from wearing the ornate, decorated kimonos reserved for the aristocracy, secretly adorned themselves with hidden tattoos.

the parts of the body tattooed varied from one island group to another.

Among dark-skinned tribes in Africa, scarification was popular (effective tattooing was not possible on very dark skin). This involved scratching or cutting the skin in patterns, sometimes rubbing a plant extract or ash into the wounds, to make scar tissue form in raised designs that lasted a lifetime.

The designs used for body painting, tattoos, and scarification were often symbolic or magical.

Piercing

Piercing involves making a hole in part of the body through which some kind of decoration can be worn. In New Zealand, men had holes in their ears the diameter of a finger and threaded these with bones, feathers, twigs, and colored cloth. In New South Wales, men wore bones through a hole in the nose. Some tribes in South America used labets, large discs held in the lower lip.

European Techniques

In Europe and America, women's body shapes were most dramatically changed by wearing hoops and paniers, and padding over the bottom called "false rumps." Men used padded calves to make their legs look better in breeches, and men and women slimmed their waists with stays.

Both men and women used a toxic paste of white lead to whiten the face, then reddened their cheeks and

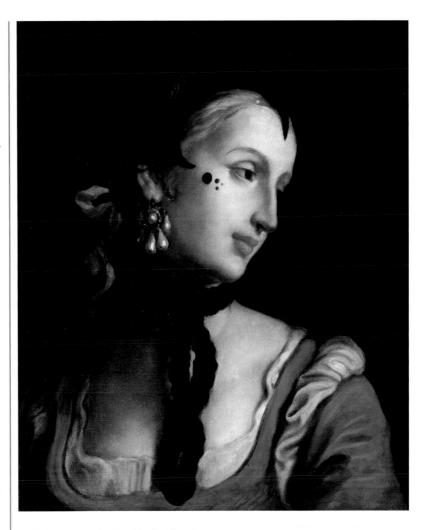

lips. Eyebrows were carefully trimmed into shape or could be shaved off and replaced with fake eyebrows made of mouse fur.

Patches made of black silk or velvet in many shapes were worn on the face to highlight the beauty of pale skin. They were probably used originally to hide smallpox scars.

In 1770 a law was passed in England to punish women who lured men into marriage by using too many false aids, such as wigs, make up and padding to make themselves look more beautiful than they really were.

This woman wears a pattern of beauty marks on her cheek.

Timeline

1708–16 A series of laws is passed banning the import of printed silk textiles into England.

1709 Paniers emerge in England, and a few years later in France.

1730 The frock emerges as the undress coat for fashionable men. Before this it was worn only by working men.

1733 The invention of the flying shuttle means that wide cloth can be produced for the first time.

1745 Indigo, used for a deep blue dye, is grown commercially in England, later becoming cheaper than indigo imported from the East Indies.

1757 Copperplate printing is invented, enabling the production of high-quality color printing on fabric.

1759 Emperor Qianlong passes sumptuary laws in China, determining the permitted designs for robes for all occasions.

1759 The legalization of printing on cotton in France and England.

1762 The publication of *Emile* by Jean-Jacques Rousseau, a novel which popularizes new ideas about the nature of childhood and childrearing, and contributes greatly to the change in the way children in Europe are dressed.

1764 The invention of the spinning jenny mechanizes spinning, so that eight threads can be spun at once.

1770s An increase in the range of chemical- and mineral-based dyes used in the West.

1770s The widespread adoption of military and naval uniforms by major Western powers.

1775 The American Revolution cuts trading links between Britain and America and forges stronger links between America and France; European fashion is influenced by sympathy for the American Revolutionaries.

1776 In Poland and Austria a law is passed dictating the colors of kontush that must be worn in different districts.

1779 The invention of the spinning mule further develops mechanized spinning, giving greater control over the process and enabling many different types of fabric to be created.

1786 The beginning of the commercial use of bleaching with chlorine to make white cotton.

1787 The beginning of the move to abolish slavery in Britain, with the formation of the Society for the Abolition of the Slave Trade. Slaves were widely used in the cotton plantations in the southern United States.

1789 The French Revolution: the overthrow of the French aristocracy ends extravagant fashion and throws the clothing industry into crisis. Fashions show sympathy for the Revolutionaries, with the trousers worn by the sans-culottes becoming popular for the first time among fashionable people.

1789 Boned corsets are banned by law in France because they are thought to damage health.

1795 Wig powder is taxed in England.

1795 Women's shift dress becomes popular, with a slim line, no padding, high waist, and sheer fabrics.

1798 The publication of *The Country Dyers Assistant* by Asa Ellis in the United States teaches women to dye the cloth they are producing at home.

1811 The Luddite Revolt: English weavers, plunged into poverty by the mechanization of weaving and knitting, smash weaving frames to protest their treatment by the cloth industry.

1825 Large-scale commercial printing on calico begins in the United States.

Glossary

à la française A very flamboyant style of dress with a wide skirt and decorated underskirt, worn over a hoop or panier to make the skirt stand out.

à l'anglaise A soft, rounded style of dress with less ornamentation than French styles. It was worn with padding to give it shape.

à la polonaise A style of ankle-length dress in which the overskirt is bunched up at the back and sides and open at the front.

amulet A charm to protect the wearer from evil.

banyan A loose indoor coat like a dressing gown, worn for casual dress by men.

beaver A tall, round hat with a small brim, originally made of beaver fur.

bodice Covering for the upper part of the body, often sleeveless and tightly fastened at the front or back, or both.

boned Stiffened with whalebone or wooden rods.

breechcloth Cloth worn tied or fastened around the waist to cover the groin.

breeches Men's pants that stop just below the knee.

breeching A ceremony to mark a young boy's transition from wearing children's dress to wearing breeches or trousers.

brocade A fabric woven with raised patterns, often including gold or silver thread.

caftan A long, loose coat worn in many Middle Eastern countries.

calico Cotton cloth, often unbleached.

chemise A long shift, often with sleeves.

cravat A frill of lace or fine fabric worn at the neck.

damask Figured or textured silk, in which the pattern is woven into the fabric.

dandy A man who is careful of his appearance, wearing fine clothes and makeup.

Empire line A slim-line dress with a raised waistline just below the bust.

epaulet An ornamental shoulder piece.

fez A round felt hat with no brim, worn in Turkey and other Middle Eastern areas.

forehead piece A piece of cloth worn under a cap to cover the forehead.

frock coat An informal man's coat.

garter A band to hold up stockings, often fastened with a buckle.

gauze A thin, transparent fabric, usually made of silk or cotton.

hoop A framework to support a skirt, made of wire, wood, or whalebone hoops.

indigo A plant-based dye that produces a deep blue coloring.

justaucorps A man's coat worn in the first half of the eighteenth century. It came to the knee and had wide skirts and wide cuffs.

kerchief A square of fabric that could be worn around the neck, over the head or shoulders, or tied at the waist.

kimono A long Japanese robe with wide sleeves, closed by wrapping over and securing with a sash.

loincloth A cloth tied around the waist and groin.

Macaroni A fashionable man in the 1770s who wore extravagant clothes, makeup, and wigs.

mantilla A Spanish lace stole worn over the head.

merveilleuses A group of French women at the end of the eighteenth century who wore flimsy, transparent shift dresses.

mittens In European court wear: gloves with no fingers, but a flap over the back of the hand. In cold regions: gloves which have a single compartment for all of the fingers and another for the thumb.

mobcap A woman's round cap, usually made of cotton or linen, that covers the whole head and was often worn for indoor work.

muslin A very fine cotton cloth.

overgown A dress worn over a shift and an underskirt, which is usually visible.

panier A framework to support a skirt, made of tiered hoops of wire, wood, or whalebone.

pantaloons Ankle-length trousers like breeches.

pelisse A woman's mantle or wide coat, often trimmed with fur and usually hooded.

plain dress An unadorned style favored by Quakers and some other religious groups in America.

Further Information

quillwork Decoration made of porcupine quills fastened onto fabric.

redingote A style of dress developed from the riding habit. The dress looks like a floor-length coat, with a fitted waist.

sack dress A loose dress with folds of fabric hanging from the top of the bodice at the back.

sans-culottes The revolutionary French of the lower and middle classes who wore trousers rather than breeches.

shaman A witch doctor or priest claiming to have contact with gods or spirits.

shift dress A thin, unshaped dress popular at the end of the eighteenth century.

shuttle A weaving implement used to carry weft thread over and under the warp threads.

spencer A short jacket worn mostly by women.

stays A bodice made of stiffened fabric and wood or bone struts used to shape the body.

stock A stiffened band of fabric worn at the neck.

stomacher A decorated triangle of fabric worn over the front of the bodice of a dress, covering the fastenings of the bodice.

swaddling A tight wrapping of babies in strips of fabric.

taffeta A plain-woven silk with a dull appearance produced by leaving the natural gum of the silk intact.

tailcoat A man's coat with two long "tails" at the back but cut away to the waist at the front.

train A length of fabric that extends at the back of a dress.

tricorn hat A three-pointed hat with a turned-up brim.

turban A length of fabric worn wrapped around the head, especially by Muslim, Sikh, and Hindu men, but adopted as a fashion in Europe in the eighteenth century.

underskirt A skirt worn under an open gown so that it is visible at the front. The underskirt is not part of the underwear and was often ornately decorated.

vent A slit in the sides or back of a coat, jacket, or waistcoat.

General Reference Sources

Bourhis, Katell le, et al. (ed.), *The Age of Napoleon: Costume from Revolution to Empire, 1789-1815* (Metropolitan Museum of Art, 1989)

Buck, Anne, *Clothes and the Child* (Ruth Bean Publishers, 1996)

Cumming, Valerie, and Ribeiro, Aileen, *The Visual History of Costume* (B. T. Batsford Ltd, 1998)

Cumming, Valerie, *The Visual History of Costume Accessories* (B. T. Batsford Ltd, 1998)

Cunnington, Phillis, and Willett, C., *Handbook of English Costume in the Eighteenth Century* (Faber and Faber, 1964)

Dubin, Lois Sherr, *North American Indian Jewelry and Adornment* (Henry N. Abrams, 1999)

Garrett, Valery, *Chinese Clothing* (Oxford University Press, 1994)

Gorsline, Douglas, *History of Fashion: A Visual Survey of Costume from Ancient Times* (Fitzhouse Books, 1991)

Hart, Avril, and North, Susan, *Historical Fashion in Detail: The Seventeenth and Eighteenth Centuries* (V & A Publications, 1998)

Racinet, Albert, *The Historical Encyclopaedia of Costume* (Studio Editions, 1988)

Sichel, Marion, *History of Women's Costume* (Batsford Academic and Educational, 1984)

Sichel, Marion, *History of Men's Costume* (Batsford Academic and Educational, 1984)

Sichel, Marion, *History of Children's Costume* (Batsford Academic and Educational, 1983)

Wykes-Joyce, Max, *Cosmetics and Adornment* (Peter Owen, 1961)

Internet Resources
http://dept.kent.edu/museum/costume/index.asp
"A Visual Dictionary of Fashion." A large collection of photos and paintings showing costumes worn by men, women, and children from the eighteenth to twentieth centuries. Organized by time, geographical area, and subject.

www.marquise.de/en/1700/index.shtml
A detailed study of eighteenth-century costume in western Europe. There are guided tours to women's and men's fashions, information on hairstyles, cosmetics, and how to make eighteenth-century costume. The author has a particular interest in using art as a source for the study of historical costume, and a large number of paintings is included.

http://hal.ucr.edu/~cathy/reg3.html
"The Regency Fashion Page." Mostly English and French fashion plates from the Regency period (late eighteenth and early nineteenth centuries), but also portraits. As well as mainstream fashions, there are sections on special areas such as bathing costumes, turbans, underwear, court dress, and shoes. Emphasis is placed on showing contemporary illustration and there is little explanation of the styles or history.

www.englishcountrydancing.org/
A hugely detailed account of English, French, and American costume, decade by decade, for men and women. Illustrated mostly with clear, black-and-white line art drawings.

http://www.costumes.org/history/100pages/ 18thlinks.htm
A comprehensive set of links to resources on eighteenth-century fashion, including accessories and cosmetics. It includes peasant and work clothes, theatrical dress, textiles, and patterns.

http://www.18cnewenglandlife.org/18cNEL/ children.htm
A detailed account of the clothing worn by children in New England in the eighteenth century, though with no illustrations.

http://dept.kent.edu/museum/costume/bonc/ 3timesearch/tseighteenth/images.html
Collection of front, back and side view photos of eighteenth century costumes in Kent State University Museum.

http://alpha.furman.edu/~kgossman/history/ rococo/
Photographs of costumes and examples from paintings showing details of eighteenth century styles.

http://mall.craftech.com/hollinbooks/product _info.php/cPath/6/products_id/25
Costumes of China, 1799, from the hand-colored antique book collection of Harris Hollin.

Index